Remembering
Orlando

REMEMBERING ORLANDO

ORLANDO

TALES FROM ELVIS TO DISNEY

JOY WALLACE DICKINSON

Charleston · London

History
PRESS

Published by The History Press
Charleston, SC 29403
www.historypress.net

Cover image: A vintage postcard from the author's collection shows Orlando's Albertson Public Library, probably in the early 1950s. The Albertson occupied the northwest corner of Central Boulevard and Rosalind Avenue, where the original section of the Orlando Public Library now stands. The Albertson was designed in the early 1920s by Murry S. King, also the architect for the elegantly columned courthouse just west of the old Orlando Public Library that now houses the Orange County Regional History Center.

First published 2006

Manufactured in the United Kingdom

ISBN-10 1.59629.172.9
ISBN-13 978.1.59629.172.0

Library of Congress Cataloging-in-Publication Data

Dickinson, Joy.
 Remembering Orlando : tales from Elvis to Disney / Joy Wallace Dickinson.
 p. cm.
 A collection of vignettes describing times from the late 1940s through the
1960s.
 Includes bibliographical references and index.
 ISBN-13: 978-1-59629-172-0 (alk. paper)
 ISBN-10: 1-59629-172-9 (alk. paper)
 1. Orlando (Fla.)--History--20th century--Anecdotes. 2. Orlando
(Fla.)--Social life and customs--20th century--Anecdotes. 3. Orlando
(Fla.)--Biography--Anecdotes. I. Title.
 F319.O7D53 2006
 975.9'24--dc22
 2006025760

Notice: The information in this book is true and complete to the best of our knowledge. It is offered without guarantee on the part of the author or The History Press. The author and The History Press disclaim all liability in connection with the use of this book.

For Jean Dickinson and George Dickinson

Children of the Pennsylvania steel country

Who found a new home in the sun

CONTENTS

CONTENTS

PREFACE

O rlando, Florida, may well be America's best-known city that nobody knows. Millions vacation at its attractions and visit its convention venues without glimpsing the real community that began as a fort during the Seminole Wars. And what's now commonly called Orlando stretches far beyond that city's official limits to a multicounty area in the center of Florida where the growth began after World War II and then took off on space rockets and theme-park rides. Sometimes, it seems like an avalanche.

The short essays in this book sprang from a history column in the *Orlando Sentinel* titled "Florida Flashback." One of the goals for the column has been to spread the word that Central Florida does have a fascinating past, especially if you know where to look for it.

The subtitle *Tales from Elvis to Disney* reflects the time from the mid-1950s, when Elvis Presley played at Orlando's Municipal Auditorium, to the coming of Walt Disney World in 1971, a period of optimism and roadside tourism that seems in the glow of memory as sunny as a Florida summer without hurricanes. In a few cases, tales reach back into the late 1940s and forward into the early 1970s. But for the most part our territory is the 1950s and 1960s in the Orlando area, with a few day trips to nearby playgrounds such as Daytona Beach, where Orlandoans have long ventured to enjoy themselves and to entertain visitors.

A few of the tales that follow touch on some of the darker aspects of the era, notably the segregation of the Jim Crow South and the gangland crime to which Florida has been no stranger. Most of them were first written between 2003 and 2006 (although they have been extensively revised), and so reflect evidence of the preoccupation with hurricanes that Central Floridians have experienced after our landmark hurricane season of 2004. They are eclectic and by no means a comprehensive history of Orlando at midcentury, but were chosen with an eye on fun and also on showing off what Central Florida has to offer for those interested in exploring the past.

Thus, there's a kind of guidebook subtext to some of what follows, with tips on interesting books, online resources and places to visit that can broaden one's horizons about Central Florida. My experience growing up in Orlando and my

own interests and preoccupations have shaped these vignettes too, and some of them verge into memoir. Although I love Florida and find it fascinating, I can't claim to be a native or a "Cracker" with deep roots in the sandy soil. Like so many other families who have found their way South, mine came from up North and we'll start our tales with that.

Acknowledgements

Anyone who writes about the Orlando area's past is greatly indebted to the staff and volunteers of the many historical organizations in Central Florida. Thanks, as always, to the folks at the Orange County Regional History Center, led by Sara Van Arsdel, and the Historical Society of Central Florida, Inc. I am especially indebted to Bob Beatty, Pat Birkhead, Tana Porter and Cynthia Cardona Melendez and to the "history warriors" of the Orlando Remembered group, especially Grace Chewning, Andy Serros and Jack Kazanzas.

Thanks, too, to Adam Watson and all the folks at the Florida Photographic Collection in Tallahassee, one of the state's great treasures; to past and present colleagues at the *Orlando Sentinel*, especially Jim Robison and Sharon McBreen; and to the staff at The History Press, especially Jenny Kaemmerlen, Deborah Silliman Wolfe and Deborah Carver.

Jean, Bill, Rachel and Elizabeth Dickinson have offered gifts of time, love and support. Friends and wise counselors on a writer's journey include Anne Berry, Jennifer Greenhill-Taylor, Joseph Hayes, the members of the Orlando Group reading circle and, especially, Nancy Ogren and Glenn Link. These essays benefited, too, from Martha Link Yesowitch's astute editing and from inspiration gleaned from Nat and Asher Yesowitch.

Many tales of Orlando's past wait to be told. That's part of the fun of history: There's always more to explore on the path to the past, waiting around the bend.

Our Fathers' Magic Carpets Made of Steel

I saw Orlando for the first time as a small child in early September 1949, stepping from a Pullman railroad car at the Atlantic Coast Line station into what seemed a world of white sand, tall white walls and white-hot heat. Floridians have for decades bragged to the folks up North about the weather in January. The summer and its spillover into September, the time of heat and hurricanes, we somehow forget to mention. In any case, maybe the imprint of that sunny September day explains why the Sligh Boulevard station, now Orlando's Amtrak station, remains my favorite vintage building in Central Florida.

It's a decades-old ritual in our family. We are railroad people, especially my brother, Bill. And so we go to the passenger station on Sligh Boulevard. We squint in the sunlight, reflected off the stucco walls, as we watch for the train to appear. We check bags and snap photos below the elegant arch of letters that spell ORLANDO. After the traveler among us has climbed up into the train, we wave at the long windows sliding by, vanishing into the horizon.

Much has changed since the station roared to life with a big celebration back in the Roaring Twenties. Tote bags and backpacks have replaced the hard boxes called train cases that ladies once gripped as they boarded, and jeans have replaced hats, suits and gloves as preferred travel attire. But the old Spanish mission–style station, designated a city landmark in 1977, is still a working part of America's railroad heritage, honored by photographers such as Peter Schreyer and Rick Lang of the Crealde School of Art in Winter Park in elegant images of black and white.

Schreyer, Crealde's executive director, grew up traveling on trains in Europe and is no stranger to railroads or to the Orlando station. When the building was scrubbed and shined in a massive volunteer effort in 1990, he documented the project. "Several hundred people worked on this Saturday after Saturday for several months," he tells a photography class during a visit to the station.

If the place needs work again—and it does indeed—much of the good done by the 1990 volunteers remains. Years later, the long curved wooden benches in the waiting room, which had become black with age, dirt and old varnish, retain the amber sheen of cleaned and polished oak.

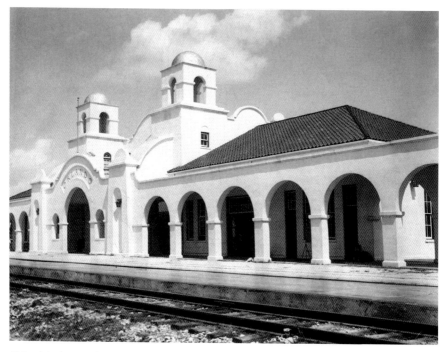

Orlando's Amtrak Station on Sligh Boulevard was built in the 1920s by the Atlantic Coast Line and was once the main gateway to the city. *Research Center, Orange County Regional History Center.*

The station's problems are enmeshed in the rather strange relationship American communities have with rail service, Schreyer states. Amtrak, which operates the passenger service, does not own the station or even the tracks. Both are the property of CSX Transportation, a railroad freight company that's not in the business of carrying passengers or of restoring historic stations.

The Great American Station Foundation (now Reconnecting America) has designated the building as one of America's most important endangered stations. But endangered doesn't mean empty or unused; ironically, the station sees far more travelers now than it did in its heyday. On a slow day, about 800 travelers move through the station, veteran Amtrak agent Sharon Crane told Schreyer's photography students; the yearly tally is about 240,000.

Railroads are an interesting subject matter, Schreyer says, "because they've been here about as long as photography has been here—they have a similar history—but their purpose of course has greatly changed in our society" with America's embrace of highways and air travel.

And the station is also a beautiful subject, Schreyer says, noting "the benches, the phone booths, the incredible attention to detail." When you think about how transportation hubs are today, they're much more utilitarian, he says.

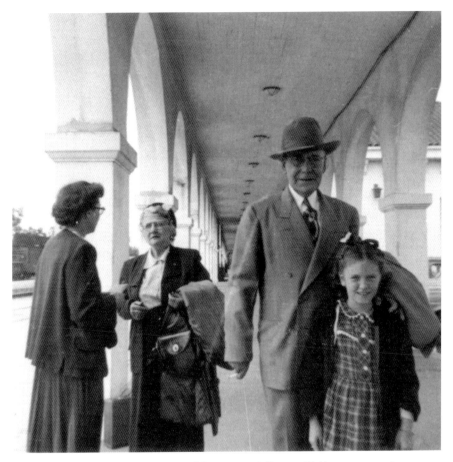

Visiting Central Florida from "up North," Florence and George Dickinson say goodbye to their Orlando family during the 1950s, when dressing for travel meant suits and hats. *Collection of Joy Wallace Dickinson.*

When Atlantic Coast Line officials planned the Orlando station in the mid-1920s, they sent architect A.M. Griffin to California to study the old Spanish missions along the Pacific Coast; it survives as the sole mission-style station in Florida. Built at a cost of nearly $500,000, the depot debuted in January 1927 with elaborate ceremonies brimming with railroad executives, bands and local dignitaries.

One of its finest features remains that arched rendering of ORLANDO over the entrance facing the trains. This isn't cookie-cutter typography: architect Griffin or an associate designed each letter down to the graceful serifs—the little strokes projecting from the main body of a letter, such as the feet on an A. An elegant swoop finishes the letter R. It doesn't hurt that the city's name, with its matching beginning and ending Os, is pretty in itself. The folks who picked it back in 1857 must have known Orlando had more marketing potential than its predecessors, Fort Gatlin and Jernigan.

I also love the colonnade of arches that extends out from the station, offering shelter from the sun for waiting passengers. There our family would wait in the 1950s and '60s for visitors from eastern Pennsylvania, our particular slice of up North. Among them were my Northern grandparents, Florence Durbin Dickinson and George Nibloc Dickinson, always decked out in their best for their rail adventure. For her: hat (with silk flower), gloves, corset, suit, stockings, high-heeled pumps, serious purse and probably one of those train cases. For him: snappy fedora, starched dress shirt, double-breasted suit, pocket handkerchief, polished shoes.

You dressed for travel then. It was an occasion. And my granddad Dickinson would have traveled no other way than by train. He was an engineer for the Pittsburgh and Lake Erie line. My earliest memories, before our move South, include being taken to the depot of our little town in Pennsylvania to wave to him as the big engine roared past.

Not too many years after he wore his double-breasted suit to visit Florida, he would depart this world at the throttle of his engine during heavy snow, the victim of a heart attack. His last act was to stop the train safely. The railroad gave my grandmother a gold watch to honor that.

Granddad would be happy to know that people are still traveling to Orlando by rail, on trains that bear names from his era—Silver Meteor, Silver Star—names that, although borne by steel vehicles that lack the streamlined grandeur of their predecessors, still trail a hint of adventure. And he would be happy to know that artists with cameras still record the world of railroads, at a station where thousands of travelers—old, young, rich, poor, black, white—have come and gone over the years, as they rode the magic carpets made of steel for a visit or perhaps a new life in the sun.

Rainbows in the Fountains

As a small child moving to Orlando from the North just as the 1950s began, I was puzzled by some of the signs of segregation. I mean the literal signs: On public restrooms, waiting rooms and water fountains, they specified either "white" or "colored." Told I was white, I wondered whether the water fountains marked "colored" dispensed liquid of a rainbow hue, perhaps with exotic powers. On a school trip to Washington, D.C., it was exciting to find children we then called "Negro" using the same public bathrooms as white students. The message was clear. Everyone in America didn't live the way we did in Florida. There were no "colored" or "white" signs in the place the president called home.

As a child growing up in Orlando, I didn't know any children or adults at all who would have used the "colored" water fountains, except for the quiet older women who came during the day to work in the homes of a couple of my school friends. When I picture them in my mind's eye, these women are standing at ironing boards. How hot those chores must have been: no air-conditioning in Central Florida then.

The crisp summer frocks and starched shirts of well-dressed white Orlandoans were pressed into place by black hands that could not have raised a glass of iced tea in the same restaurants where white people dined.

When my mother took a full-time job at a big department store, one of these women, Mary Etta Sayles Jones, came to our house two afternoons a week, in the pastel uniform she pressed herself. Years later I learned that in the 1960s my mother had once gone to visit her at what was then Orange Memorial Hospital. The "colored" area of the hospital was in the basement, below rusty pipes. To say that it was not equal to the white wards and rooms upstairs would be an understatement.

That was how it worked: separate but very rarely "equal." That is in part why the U.S. Supreme Court, in its *Brown v. Board of Education* ruling in 1954, struck down the separate-but-equal doctrine that provided the foundation for legal segregation, especially in the former Confederate states where slavery had also once been legal.

During celebrations of the fiftieth anniversary of *Brown v. Board*, a panel presented by the Florida A&M University College of Law offered an "insider's perspective" on the effects of the decision in Orange County schools. Five African

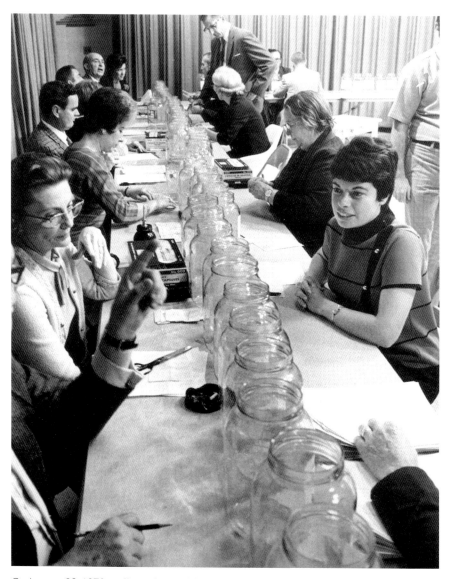

On January 23, 1970, staff members at Valencia Junior College (now Valencia Community College) draw names of Orange County schoolteachers from large glass jars. The televised marathon session ended at 5:30 a.m. on Saturday, January 24, with final touches late on Sunday. More than five hundred teachers were reassigned to meet a federal court deadline for racial balance. Orlando Sentinel *files*.

Americans recalled memories of what happened when the landmark case hurled a sledgehammer at the walls of segregation. The walls didn't crumble—court cases and years of legal wrangling had to disassemble them brick by brick.

The Brown case was in 1954. I was in elementary school then, but I had graduated from a segregated high school and then from a segregated state university by the time of the Orange County events the panel speakers recalled.

One event, in 1970, sounded almost surreal from today's perspective. Speakers called it the night of the fishbowl. In a televised marathon session that ended at 5:30 a.m. Saturday, January 24, with final touches late on Sunday, names of Orange County teachers were drawn from large glass jars or bowls in a scramble to reassign 508 teachers to meet a federal court deadline for racial balance.

Then in eighth grade, panel speaker Vicki-Elaine Felder remembers watching the event on TV; her mother, Anne M. Felder, a guidance counselor at Jones High, the educational soul of Orlando's black community, would have to report to Colonial High the next Tuesday. Talk about disruptive. This was in the middle of the school year. Teachers had one day off—Monday—to get moved and report to their new assignment.

"I had tears in my eyes all night," one teacher told the *Orlando Sentinel* before her move in 1970. "What will happen to my schoolchildren? This is terrible."

During the drawing, "the confusion was so great that near fistfights occurred," the *Sentinel* reported. Late Saturday, "at least one fistfight between teachers was reported."

Like Florida's governor, Claude Kirk, who was quoted on the January 25 front page as saying he'd rather go to jail than permit any Florida schoolchild to be bused against the child's will, the newspaper seemed to attribute the chaotic situation to the federal courts. "Although the actual integration crisis" had begun with the 1954 Supreme Court ruling, an analysis said, "Orange County didn't really have a problem until January 6, 1970," when a U.S. district judge in New Orleans had mandated "complete student desegregation" by February 1.

That perspective was likely not shared by African American attorney Norris Woolfork III, who was leading a court battle against Orange County's "freedom of choice" desegregation plan for the National Association for the Advancement of Colored People.

Now, years later, those of us who long for happy endings can't find one yet in this long, complex story. As speakers at the FAMU panel said, race relations in this country have a long way to go. So do schools. But so very much was changed after *Brown v. Board of Education* and other civil rights milestones. People who would never have known each other in 1950s Orlando now work together, play together, laugh and cry together. There are no signs telling people where they have to sit or eat or go to school because of the color of their skin. And the water fountains have the same "color" for us all.

WHERE THE WILDLIFE MEETS THE GOOD LIFE

If you've lived in Orlando for any length of time, you know that sooner rather than later, company will be coming. From Maine to Minnesota, Wisconsin to West Virginia, the folks back home will be booking a visit at Chez You, and the wise Central Floridian socks away a list of dependable spots to take the out-of-towners for a morning's or afternoon's entertainment. One of our family staples has long been Winter Park's Scenic Boat Tour, which continues dependably unchanged—at least as much as anything can be in constantly changing Orange County, Florida.

Taking off for an hour's ride, the Scenic Boat Tour meanders through lakes Osceola, Virginia and Maitland in Winter Park by way of two canals, the Fern Canal and the longer, curvy Venetian Canal, while genial guides point out examples of flora and fauna and the expansive homes and historic sites that line the lake banks. It's a look at the city's aquatic backyard that one can't see while rushing through town in a car. As a newspaper headline once described it, the tour offers a glimpse of "the wildlife and the good life" in the Orlando area's classiest city.

In one breath, your guide will point out a cluster of hibiscus or a majestic heron, and in the next he'll be describing the multimillion-dollar glamour of homes lining the lakes. On a New Year's Day visit in 2005, changes were apparent in both realms after the scrubbing Central Florida's landscape took in 2004 from Hurricane Charley and his pals, but it's in the houses that one can see the biggest difference from the days fifty years ago when our family sailed this terrain during visits from my Grandma Dickinson and other winter guests.

It used to be that a house such as Wind Song, the Genius-McKean estate where the peacocks roamed, or the home of the late Archibald and Edyth Bush, built with a fortune made at 3M, seemed grand and deluxe. But now, the lakeside homes are so immense one almost wonders if a race of giants has landed in Winter Park. They make what used to pass for a grand estate look positively modest from the vantage of the tour's pontoon boats.

Our New Year's Day tour took place on an anniversary day for the Scenic Boat Tour, which officially began January 1, 1938, according to the Winter Park

Public Library's excellent online history-and-archives site (see wppl.org/wphistory). W.C. Meloon, the founder of Correct Craft Inc.—then the Pine Castle Boat and Construction Company—announced the tours in 1937 and probably did some warm-up trips late that year in a thirty-five-passenger boat named the *Scenic*, according to Claire MacDowell's *Chronological History of Winter Park*.

A half-century before Meloon piloted his guests through the waters that promoters proclaimed the Venice of America, the owners of the new two-hundred-room Seminole Hotel had invited visitors to winter in Winter Park in an 1888 brochure that's viewable on the library's online site. The hotel and a later incarnation of it are long gone, but a boathouse from the last version of the hotel can still be seen on the tour.

The main idea of Winter Park's founders "was to have in the center of this thriving community a beautiful winter resort for people who wish to escape from the cold and blustering weather so fruitful of colds, coughs, diphtheria, consumption," the 1888 brochure declared.

It would be "a collection of beautiful villas in the midst of orange groves, upon acre lots, running to the shores of crystal lakes…a resort for the winter" of the sort Saratoga, New York, offered in the summer.

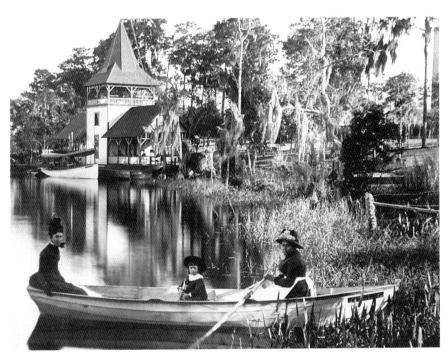

The Winter Park Scenic Boat Tour through lakes Osceola, Virginia and Maitland passes by the site of the Seminole Hotel, a tourist mecca for visitors who enjoyed the lakes' waters a century ago and recorded their Central Florida experiences in scenes like this. *Research Center, Orange County Regional History Center.*

Come and take a drive or a walk, the writers proclaimed, and you will say, just as President Chester Arthur did on a visit to Winter Park in 1883, "This is the prettiest spot I have seen in Florida, and I would like to rest under one of these grand old pines for a week."

Robin Chapman's two guidebooks, *The Absolutely Essential Guide to Winter Park* and her companion volume for Orlando, offer many fine ideas, such as the Scenic Boat Tour, for entertaining those visitors at Chez You. For more information about the tours, see scenicboattours.com.

HIGH-RISE HOTEL GLAMOUR

Long before tall resort hotels clustered around Central Florida's theme parks, the Plaza Hotel on Orlando's Lake Eola and the Langford in Winter Park brought big city glamour to Central Florida in the 1950s. The building that began as the Eola Plaza survives as stylish apartments, but the Langford is gone. In May 2000, just days before the hotel closed, founder Robert Langford talked about his life as a host to travelers. He died less than a year later, shortly before his eighty-ninth birthday.

For folks growing up in Orlando, Florida, in the 1950s and '60s, the big-city settings in popular movies were sometimes elusive. On the silver screen, Doris Day and Rock Hudson rode shiny elevators to chic New York apartments with rooftop views. Even the children's book heroine Eloise lived in New York's Plaza Hotel, of all places.

There, at least, was something we could relate to: We, too, had a Plaza, a nine-story, elevator-adorned piece of Moderne elegance right in the middle of Orlando, at the southeast corner of Lake Eola Park. The building premiered as the Eola Plaza in the fall of 1950, even before the elegant Langford Hotel debuted in Winter Park in 1956.

Through changes of ownership and name—Eola Plaza, Cherry Plaza, Park Plaza—the building remained a touch of urbanity in the midst of moss-draped oaks and becolumned Southern houses. And the gracious restaurant space in the building's almond-shaped ground-floor extension overlooking Lake Eola has been the site of celebrations for graduations, birthdays, anniversaries and prom nights for generations.

First an apartment hotel and later residential apartments, the Plaza was "a great place to live," one resident told a reporter in the early 1990s. "There isn't another place like it in Orlando."

From the beginning, the building was home to a variety of shops and businesses. Ads from the early '50s show the Eola Pharmacy, which opened in 1951, as well as Plaza Petites, the Eola Plaza Flower Shop, Jeanne Elkins Dress Shop, Markham's Restaurant, the Mary Bradshaw Beauty Salon and a real live night club: the Eola Plaza Bamboo Room, no doubt the scene of swing dancing and martini-imbibing during Saturday nights on the town.

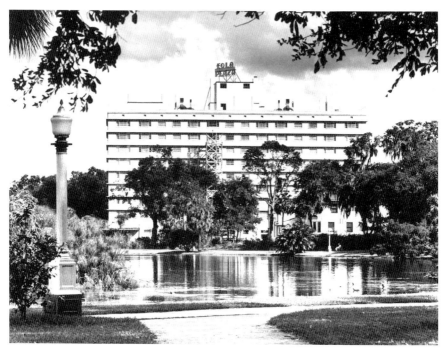

The building that began as the Eola Plaza debuted in the fall of 1950 next to Orlando's Lake Eola Park. During the 1960s when Lyndon Johnson campaigned there, it was known as the Cherry Plaza after its owner at the time. The former hotel, which survives as an apartment residence, has a spot in Central Florida history as the site of a press conference by Walt Disney in 1965 to announce plans for Walt Disney World. That event took place in the hotel's Egyptian Room, in a wing that no longer exists. *Research Center, Orange County Regional History Center.*

Through the years, the hotel played host to big-name guests and events, including an October 1964 visit by President Lyndon B. Johnson. Even more important for Central Florida was a visit by Walt Disney about a year later, when in November 1965, he officially announced plans for his new Florida resort from the Egyptian Room in the building's now-gone ballroom wing. That's been called the transforming moment in Central Florida's history, but the hotel where Disney spoke had perhaps already heralded the start of the new era.

When it opened in 1950, the Eola Plaza was one of the tallest buildings from Jacksonville to Tampa. With so many taller buildings nearby now, it's hard to imagine how much it transformed Orlando's skyline around Lake Eola at a time when most of the area's buildings were two-story residences.

Many of these houses had been converted into offices or inns that catered to winter visitors and were no longer family homes. But they did embody a slower-paced world, before World War II had taken the world apart, when entertainment for visitors might mean a band concert in the park and a place to stay might mean a room in a large house beneath the Spanish moss.

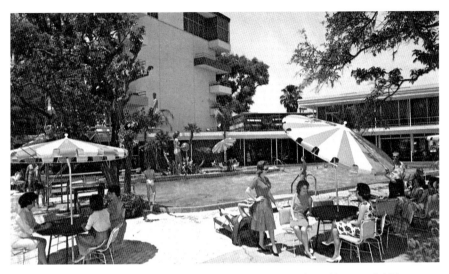

When the late hotelier Robert Langford opened the hotel that bore his name in Winter Park in the mid-1950s, some folks told him he was crazy to begin an all-year-round resort in Central Florida's heat. But Langford bet on the future—and on air conditioning—to transform Central Florida's tourist market. *Collection of Joy Wallace Dickinson.*

The Eola Plaza, all nine International-style poured-concrete stories of it, was full of the spirit of postwar progress and modernism. It bustled with the promise of visitors who wanted not a cozy boardinghouse but a first-class hotel, just like the ones in the movies. Maybe that wave of change epitomized by Uncle Walt Disney had already started at Lake Eola in 1950.

For Robert E. Langford Sr., the late dean of Central Florida hoteliers, hotels weren't just a business; they were a way of life. It started long before he even dreamed of Florida, with a Chicago hotel his grandparents opened near Lake Michigan in 1893 in time for the World's Columbian Exposition. That immense celebration of American technology, commerce and art brought an estimated twenty-seven million visitors to the city—nearly a quarter of the country's population at the time. They needed hotel rooms, and Langford's family and other innkeepers were happy to oblige.

Among the marvels visitors would see at the exposition was Louis Comfort Tiffany's dazzling chapel of stained glass and mosaics that more than a century later would be on display near a Langford hotel, this time in Winter Park at the Morse Museum of American Art.

About 1927, John D. Rockefeller bought Langford's grandparents' first hotel, and in 1928 the family bought another one in the same area. They named it the Del Prado and decorated it in Native American motifs inspired by James Fenimore Cooper's novels. The hotel's name was inspired by the main street at the 1915 world's fair in California—another version of Chicago's great 1893 midway.

The timing couldn't have been worse for a new business. When the stock market crashed in 1929, Langford, then seventeen, remembers grim details: Two Del Prado guests killed themselves at the news of their economic ruin by jumping out of windows. The hotel went into receivership, but another Chicago world's fair in 1933–34 saved the day. The years following brought business from steady clients such as airline pilots at Midway Airport and American League baseball teams.

Langford graduated from the University of Chicago in 1934, but his jobs at the Del Prado—from dishwasher to desk clerk—also provided the foundation of his innkeeper's education. He would put those lessons to good use at the Florida hotel he would envision and build after he moved to Winter Park in 1946.

He learned early that meeting famous people was one of the fun parts of the business. In boyhood, Langford treasured an autograph from Douglas Fairbanks, the 1920s Hollywood giant who in roles from Robin Hood to Zorro became synonymous with swashbuckling. At eighty-eight, Langford still remembered what Fairbanks wrote: "My best to Bobby."

He also treasured the list of notable visitors to the Langford Hotel in Winter Park—from Mamie Eisenhower to June Carter Cash to Jesse Jackson to Walt Disney, from the sublime (silent screen legend Lillian Gish) to the professionally ridiculous (Henny Youngman, Rick Moranis).

Langford was too much the professional guardian of guests' privacy to indulge in gossipy details, but he did divulge polite details about tea with Eleanor Roosevelt, who asked him about the political climate in town, and a dinner with Nancy and Ronald Reagan celebrating their twenty-fifth wedding anniversary in suites 501 and 502 at the Langford.

When Langford started planning his Winter Park hotel in the early 1950s, most inns in Central Florida closed during the summer. Pundits told him he was crazy to build a year-round operation. But he had a definite feeling about the future of Central Florida. Air conditioning was key to the whole thing, as he saw it.

He began his Winter Park hotel with 82 rooms. An early guest was Roy Disney, Walt's brother and guiding light in business matters. "He asked me how many rooms I had," Langford recalled, "and when I told him 82, he said, 'You'd better double it.'"

Eventually, the Langford grew to 218 rooms—rooms that at the hotel's close in 2000 were still surrounded in green, more than four decades-worth of bamboo, crotons, elephant ears and other tropical flora. No wonder the Winter Park landmark was long a favorite of European visitors. Especially in the pool area, it looked like Florida should—it even had its own flock of pink flamingos in the 1960s. The landscaping was lush and tropical, generous and welcoming. A tropical paradise should, after all, not be too trim and precise.

Complimented about the wealth of flora just days before his hotel's close, Langford seemed gratified. "You see too many hotels now, several stories high with only two palm trees stuck in front.," he said. That wasn't Robert Langford's idea of a hotel. You'd certainly never see a Douglas Fairbanks or an Eleanor Roosevelt there, either.

GOOD EVENING, EVERYONE

It's been more than thirty years since Barbara Stump's husband died much too young at fifty-six on a bright clear New Year's Eve, but she still gets letters from folks who miss him. Charles W. Stump Jr. was Florida's first television meteorologist and a big star of early Orlando TV. Beginning his broadcast career in Tampa in 1953, he came to WESH-Channel 2 in 1960 and in 1969 moved to WFTV-Channel 9, where he was also business manager. In a state when the whirling clouds on TV screens can turn deadly, weather forecasters are important people.

There was always a crowd around him," Barbara Stump remembers. Even if they didn't know him personally, her husband, Charlie, was one of the family. "Even little children would come up to him and hold his hand or touch him," his oldest son, Chuck, remembers. "It was just like they all really loved him."

The man people called "Charlie the weatherman" earned their devotion in part with his plain-spoken Southern-drawl delivery but also with his skill and professionalism. When Tom Terry, chief meteorologist of WFTV-Channel 9, predicted Hurricane Charley's path in advance of other forecasters in 2004, Barbara Stump was reminded of her husband during monster Hurricane Donna in 1960.

"He had just come to Orlando," Barbara Stump recalled, to begin work at WESH. She and their children were still in Tampa, getting ready to move to Central Florida. "The weather bureau says Donna's going west and won't hit Orlando," Charlie Stump told his wife in a phone call, but he felt certain that wasn't the case. "He stuck to his guns," Barbara Stump recalls, and he correctly predicted Donna's path. It helped make his reputation.

So, too, did his low-key style and down-home accent. His greeting, "Good evening, everyone"—which sounded more like "Good eve'nin' ever-wonn"—became part of the local lexicon. To Northern transplants, Stump's voice may have sounded like a touch of Tennessee or Georgia or Texas. But that was the sound of old Florida, or at least a slice of it.

Stump was born in Tampa in 1918; his mother was the granddaughter of an early mayor of Key West. He came to meteorology through his early love of flying

and earned a pilot's license when he was just sixteen. When World War II broke out, he tried to enlist but was turned away because of high blood pressure. Before long, he managed to gain entrance to pilot training for the Army Air Corps.

During his service as a pilot in the Pacific during World War II and afterward, Stump was trained in meteorology. After the war, he transferred his expertise to broadcasting in the pioneering days of TV in Florida. When he went on the air in Tampa, station managers suggested he don a Hawaiian shirt. "No way," said Stump; "I'm a professional meteorologist and I'll dress like one."

Hartwell Conklin of Orlando, who was production manager at WESH when the station recruited Stump from Tampa in 1960, recalls that Stump likewise declined to do a soft drink commercial for his segment. What he did do, however, was answer just-plain folks' questions about the weather.

"I suppose Charlie Stump took about two thousand phone calls a year from people wanting personal weather forecasts for their fishing, boating, flying, camping or traveling activities," WFTV General Manager Walter Windsor said in a televised tribute to Stump in January 1975. "I know of nobody else in the world who would have taken the time to talk to each of these callers."

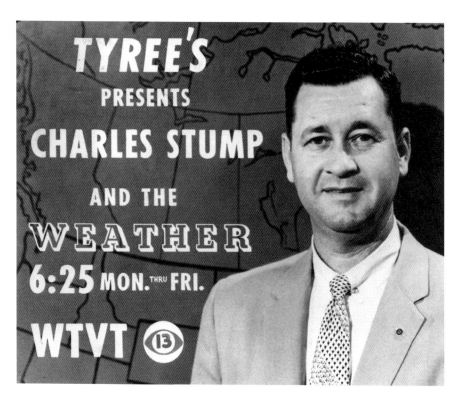

When weatherman Charlie Stump became one of Orlando's first television stars, his on-air tools included a linoleum-covered map board on which he wrote with a homemade white marker. *Courtesy of Barbara Stump.*

A printed copy of Windsor's words is pasted in a red scrapbook Barbara Stump made for their family after her husband's death on New Year's Eve in 1974. He had a heart attack while the family was on vacation in Franklin, North Carolina. The scrapbook contains comments by WDBO-Channel 6's longtime anchor Ben Aycrigg, the Walter Cronkite of Orlando news, remembering not only Charlie Stump's expertise but also his devotion as a dad who never missed his son David's little league games.

There are words by WESH's stalwart meteorologist Dave Marsh, recalling that it was Stump who gave him his most important opportunity as a weatherman early in his career. Stump excelled as a professional meteorologist, Marsh wrote, but his real forte was helping folks. "Be calm," Stump wrote in a "Hurricane Precautions" brochure for viewers in 1962. "Your ability to meet emergencies will inspire and help others."

In Charlie Stump's day, his on-air tools featured a linoleum-covered map board on which he wrote with a homemade white marker he concocted himself. Now Marsh, Terry and Stump's other heirs use equipment with mind-boggling sophistication.

But as Floridians have seen in their rocky recent hurricane seasons, the main point of it all remains just what was Charlie Stump's forte—helping us to cope with the good, the bad and the really, really ugly that nature may send our way.

Time-Tripping at the Library

A front-page Orlando Sentinel *article got the attention of some longtime Orlandoans a few years ago with its statement that the City Beautiful doesn't have a sense of history. "You don't find historical markers in Orlando or the old buildings that go with them," seasoned writer and Orlando-watcher Jeff Kunerth wrote. Tucked downtown and elsewhere, though, we do have a kind of historic marker, placed for years by a committee of the Historical Society of Central Florida called Orlando Remembered.*

Around noon on a steam bath August day in downtown Orlando, I found myself in the cool of the Orlando Public Library, blinking at words in a glass case on the wall. "Imagine it's the summer of 1945," the words say. "Imagine that as you descend the steps of the Albertson Public Library [the precursor of the Orlando Public] after several hours of reading, the glare of the bright sunlight and the thick, humid air envelopes you." Imagine that "air conditioning has not yet arrived in Orlando."

I had rushed past this case many times before without giving it a glance. But like a lot of things in our revved-up world, sometimes you've got to slow down to receive the gifts being offered you. Then, the words and pictures behind the "Orlando Remembered" label on the glass can work a bit of magic. Keep reading, and looking, and the present fades away.

Orlando Remembered, the group responsible for the library display and others, has been embedding reminders of the city's history downtown for about twenty years. Other stops include ten more sites within a few blocks of the library and the Orange County Regional History Center across the street. Two more sites are just a little farther away, at the new Orange County Courthouse and the Bank of America Tower.

The group also recently added displays at the renovated downtown post office and, a few blocks east on Robinson Street, at Howard Middle School, the former Orlando High School building. Members hope soon to add others that will focus on the history of the Central Florida Fair, the Parramore business district and the area around the Lynx bus terminal.

In each display, photos, written descriptions and physical objects combine to show the nearby urban landscape as it looked in Orlando from about 1930 through 1950. Many of the descriptions were written by the late Ormund Powers, a

longtime *Sentinel* writer and editor and the author of a biography of the newspaper's late publisher, Martin Andersen, an excellent source on the history of Orlando.

While Powers sets the scene in words, paintings by artists Jim Stoll and Ellen Smith serve as powerful tickets to time travel. Gazing at the display at the library, my eyes were drawn to a small object in Stoll's painting. It was the metal drop box in front of the old Albertson Public Library, for the return of books after hours. Totally forgotten until I spied the painting, the curbside box came back in all its green glory, and so did the countless times during high school I had screeched up to it to return books at the last possible minute.

On a hot day in 1945, the year Powers set his text for the library display, Orlandoans leaving the library to head west toward Orange could get a cold drink at Wayne Moses's Corner Canteen, shown in a photo in the display. Behind it was Sam Shiver's Shell Station; now, the closest gas station to the library is blocks away. Nearby, at the Angebilt Hotel, rooftop dances offered Orlandoans cool evening entertainment in the post–World War II years. At the landmark Rogers Building at Pine Street and Magnolia, members of Orlando's English colony had tossed back a pint in the 1880s before the great freeze of 1894–95 sent many of them reeling back across the Atlantic. And not far from that, the First Presbyterian Church's Clayton Life Center contains the first church-related Orlando Remembered display, a joint venture with the church's heritage committee. The distinctive three-panel display depicts the church's history from 1876 through 1999.

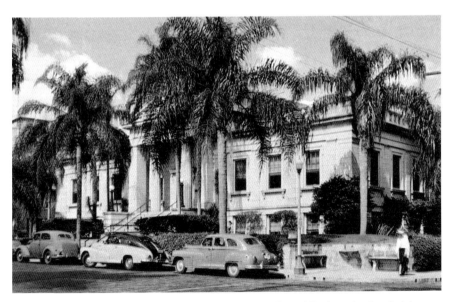

Built in the 1920s, Orlando's Albertson Public Library faced Central Boulevard at Rosalind Avenue, on part of the site now occupied by the Orlando Public Library. The Albertson and other lost buildings are memorialized in displays throughout downtown prepared by Orlando Remembered committee of the Historical Society of Central Florida, Inc. *Collection of Joy Wallace Dickinson.*

Along with the displays, a walk downtown offers a chance to get reacquainted with some of the city's older buildings up close. Asbury Hall, the First United Methodist Church's 1948 education building, for example, has lovely features: white columns and big arched windows. Other buildings, too, boast interesting architectural details, such as the terra cotta art deco ornaments on the Kress building on Orange Avenue.

That August day, after my short stroll downtown, I circled back to the library. Built in 1965 and expanded to its present size roughly twenty years later, the Orlando Public Library remains one of Central Florida's most distinguished buildings and historically one of its most controversial. I loved the Albertson, with its glass-block flooring and classical columns, but the vertical lines of its Frank Lloyd Wrightish replacement have found a place in my heart too. Several years ago someone who had served in the Persian Gulf War told me that if Orlando were ever threatened by ominous forces, the big library was the place to head. Its heavy walls could stand up to plenty, he said.

Let's hope that's something we never have to contemplate. But in the meantime, the image of the building as a fortress seems reassuring rather than scary. It's a fortress of learning, a place where the gardens of the mind can grow—and in its own way, a fortress of history, too.

And if it's true that we can't claim to compete with Charleston or Savannah or our own St. Augustine when it comes to history, we can still find reminders of the heritage that Orlando Remembered stalwart Andy Serros has called "the cement that holds a community together."

DIAMOND IN THE REAL

In 2004, for the first time in more than eighty years, Orlando had no professional baseball home team. The Orlando Rays were gone, morphed into the Montgomery Biscuits up in Alabama. One can only imagine the possible headlines: "Crowd Eats Up Biscuits!" "Biscuits Crumble in Ninth Inning!" Meanwhile, as Orlando swept up the crumbs, we still had a ballpark with plenty of history. For the better part of a century, players have rounded the bases at the field named for Orlando's own Hall of Famer. Tinker Field, named for Joe Tinker, is on the National Register of Historic Places.

Most of my childhood baseball memories are black-and-white scenes from the curved screen of our family's 1950s television while Dizzy Dean's voice wafted through the house on a warm July breeze. The contrast at Orlando's Tinker Field was startling on a recent summer visit during a game between the Orlando Shockers and the Winter Park Diamond Dawgs of the Florida Collegiate Summer League.

The field looked so close you could almost touch it: bright green grass, reddish clay, white lines. You could hear the crack of the bat hitting the ball, the metallic slap of a high foul hitting the grandstand roof. That sense of intimacy is what makes old fields such as Tinker special, as Pat Clarke, sports director of WESH-Channel 2, has noted.

Clarke recalled Minnesota Twins owner Calvin Griffith lunching on tomato soup and tuna sandwiches in the field's tiny media lunchroom, in the days when the Twins came to the park for spring training. Newer, bigger stadiums may be beautiful, but "the sense that you can reach out and touch the catcher or the center fielder is virtually nonexistent," he said.

Through the years, the spring-training games brought a parade of baseball giants to Tinker Field. Hank Aaron, Joe DiMaggio, Lou Gehrig, Mickey Mantle, Roger Maris, Stan Musial, Pee Wee Reese, Ted Williams and many others played at Tinker.

In a 1986 *Orlando Sentinel* interview, Twins owner Griffith described Babe Ruth's arrival at Tinker one day in the 1940s in a Lincoln convertible. "He drove it right into the park, through a gate in left field, right there where those light towers are now. Then, he drove around the inside of the place. People cheered like crazy," Griffith said.

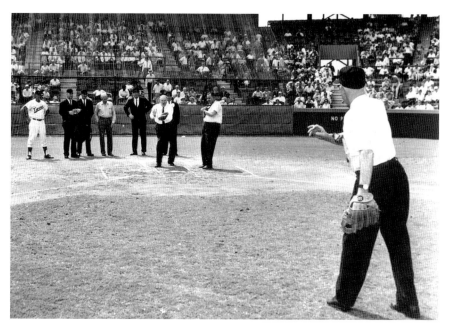

Orlando Mayor Bob Carr pitches to Minnesota Twins owner Cal Griffith on the opening day of spring training in 1963 at Orlando's Tinker Field, which has a spot on the National Register of Historic Places. Orlando Sentinel *files*.

They cheered, too, the day in 1947 when Jackie Robinson, the legendary black player who broke the color line in Major League baseball, played for the Brooklyn Dodgers against the home team Washington Senators (which became the Twins in 1961).

The grandstands at Tinker have seen their share of famous faces as well. In 1961 Jack Kerouac could often be found in the bleachers along the left-field line, Bob Kealing writes in his book *Kerouac in Florida: Where the Road Ends*.

A few years later, the Reverend Martin Luther King Jr. spoke at Tinker Field, to a public rally in March 1964, weeks before President Johnson signed the 1964 Civil Rights Act into law. Later that year, King received the Nobel Peace Prize.

When King spoke at Tinker, his listeners sat in a then-new grandstand that remains today, with its open press box and revolving fans. Dedicated in 1963, it replaced a wooden grandstand that debuted to great optimism on a spring day in 1923. The city's businesses would be closed for the grand event, the *Sentinel* reported; city commissioners had declared a holiday. Everyone would be on the west side of town, at Tinker Field.

Recently, Orlando Mayor Buddy Dyer, U.S. Representative Ric Keller and others have expressed hope that the ballpark's historic recognition will help usher in a new era of baseball at Tinker with another minor league team.

"It's a classic baseball park," says Gil Bogen, author of *Tinker, Evers and Chance: A Triple Biography*. "You just don't find those anymore."

THE RITES OF AUTUMN

"Everybody—But Everybody—Loves Football," exclaims an Orlando newspaper headline from the early 1960s. For some of us, it's not quite so simple. Surely I'm not the only one who at some point could have cheerfully ignited the television set rather than endure one more TV gridiron contest on a fall weekend. But it's undeniable that autumn in Central Florida has long meant a strange concoction of events in which college football looms large. Rivalries on the gridiron compete for our attention with contests at the ballot box. Throw in the Halloween sugar rush and post-hurricane anxiety, and it's an interesting time.

Some of Florida's football rivalries have reached a fame far beyond our state. The Florida Classic between Florida A&M University and Bethune-Cookman College, played in Orlando in recent years, is often called the nation's premier contest between historically black colleges, and many lists of the top collegiate rivalries include other Florida teams.

The granddaddy in size and age is the annual duel between the University of Florida Gators and the University of Georgia Bulldogs: the event hailed as the World's Largest Outdoor Cocktail Party. When in 2006 University of Georgia President Michael Adams and others asked folks to stop using that name, given the alcohol-related problems on college campuses, wags sent the *Atlanta Journal-Constitution* more than five hundred suggestions for substitutes, ranging from "The Only Reason to Go to Jacksonville" to my favorite, "Jaws vs. Paws."

Since 1933, the game's usual home has been Jacksonville, where former *Times-Union* sports editor Bill Kastelz apparently coined the "Outdoor Cocktail Party" label as a throwaway line years ago. It stuck so well that today it even turns up as an entry in online encyclopedias.

I've never been to it. I'm not only a potential TV burner but a graduate of the Gators' other prime rival, Florida State University in Tallahassee, in the years before FSU's Seminoles became a football power under coach Bobby Bowden. Then, the gridiron glory was across town at Florida A&M, where in the 1960s the late coaching legend Jake Gaither was heading toward the close of his 203–36–4 record for 25 seasons, one of the highest winning percentages (.844) in collegiate football history.

Florida A&M University's legendary coach, Jake Gaither, conducts football practice in 1953 in Tallahassee. In recent years, the annual FAMU game with Bethune-Cookman College, the Florida Classic, has been played in Orlando. *Florida Photographic Collection, State Archives.*

But to many Central Floridians, there's no autumn day as dear as the one when the Jaws take on the Paws. "The battle between these two universities from neighboring states has become a border war unparalleled in sports," Pat Summerall intones on a DVD titled *Rivalries: The Tradition of Georgia vs. Florida.* Although the two teams quibble about the origin of the game—Georgia says 1904 and Florida says 1915—it has indisputably been a big deal for a very long time.

In 1960, for example, the *Orlando Sentinel* gave the contest a prominence not far behind the neck-and-neck presidential race between Richard Nixon and John Kennedy. Just a few days before a headline declared "It's Pres. Kennedy," the long-running front-page humor feature called "Cracker Jim Sez" proclaimed: "Hit shore looks to me like today is gonna be a mity fitten day for all them folks what's travelin up there to Jacksonville for that feet bawl game."

"Cracker Jim" may have been a pretend hayseed, but if he went to those "feet bawl" games with many other Orlando Gator fans, he traveled in modern efficiency on a streamlined Atlantic Coast Line train. "We'd rendezvous at the Winter Park railroad station with our picnic and coolers" about 10:00 a.m., Orlando history booster Andy Serros remembers. "When we got to Jacksonville, we would pour into buses at the old Jax railroad station and go to the old Gator Bowl. The buses would bring us back to the trains, and we'd get home after dark."

Instead of putting out a spread on the tailgate of a station wagon, game-bound fans partied as they rode the rails. "The ladies were dressed up with large corsages, hats and high-heeled shoes," Serros says. The Gators always had a conga line from the Orlando section though the Tampa section of the train, singing "We Are the Boys From Ol' Florida."

Now, I'm inspired. Go Gators! Go Knights! Go Noles, Rattlers and Wildcats too! Heck, I'll even holler, Go Dawgs! As many of us were told long ago in kindergarten, it's not the victory but how you play the game, how you travel along through life, that matters. Perhaps that's the thing to remember best about all our contests of autumn.

THE GAME OF NUMBERS

The game sounds harmless enough, and there was nothing dangerous in the playing—no crazy dares or high-speed races. To play bolita, you simply picked some numbers and bet on them. In the early days you could wager as little as a penny, in a kind of underground version of the Florida Lottery. An attorney for the late Harlan Blackburn, Central Florida's king of the game, once said in court that, had Blackburn been born fifty years later, "he probably would have made an outstanding director of the Florida Lottery." But in Blackburn's day, the numbers game wasn't legal. And in the secret world of bolita in pre-1970s Florida, for some who angled for a slice of the take, the game could be deadly.

Scott M. Deitche's book *Cigar City Mafia* traces the history of the underworld in Tampa, long ruled by the Trafficantes, Santo Sr. and Santo Jr., but a couple of chapters focus on the so-called cracker mob of Central Florida. Harlan Blackburn, Orlando's bolita boss, and the Trafficantes "were really close," Deitche says. "Their middleman was Sam Cacciatore, who was related to the Trafficantes…Payoffs went one way, payoffs went the other."

As Deitche tells the story, it might have been a battle over who got those payoffs—and who controlled bolita in Central Florida—that in May 1953 put Ed Milam's body in a ditch south of Kissimmee, where it was discovered in the Reedy Creek Swamp by an army sergeant and his wife gathering swamp cabbage on a Sunday afternoon.

The murder is still unsolved. Milam had been reported missing from his Orlando home for about a week, and the Reedy Creek discovery spurred sensational news reports in both the Tampa and Orlando papers. "Orange County Sheriff Dave Starr labeled the murder a gangland killing brought on by Milam's bolita operations," the *Orlando Morning Sentinel* reported on May 18, 1953, under a headline declaring "Gang Ride Forecasts Bolita War."

Milam had last been seen entering a car with two men on West Washington Street in Orlando. Investigators later reported he had been shot four times with a .38-caliber pistol. "Authorities believe Milam, who was under a 10-year probation sentence for bolita operations in Polk County, was killed near Orlo Vista," and the body carried down a lonely road to what the killers hoped would be oblivion.

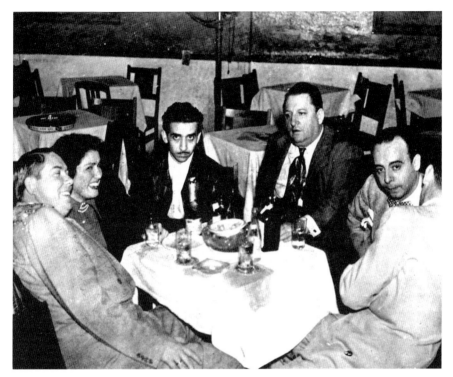

The late Harlan Blackburn (left), gambling kingpin of Orange and Polk Counties in the 1950s, was photographed with a group of associates at an unnamed nightspot. *Florida Photographic Collection, State Archives.*

Some observers thought it might be only the first of a number of "such 'one-way rides' in a fight to the finish for control of gambling operations throughout Central Florida," the *Sentinel* story said. Indeed, after the killing, "the bolita business in Central Florida is as jumpy as a hollow tooth with an exposed nerve," the *Tampa Tribune* noted. The jitters had started the previous fall when Blackburn and "his hirelings" had been arrested in raids in three counties, the *Tribune* said.

Blackburn was appealing a rather minor gambling conviction in Polk County, but the raids had opened the door for federal authorities to step in and the bolita boys were nervous. Just as things seemed to be settling down, Milam "was taken for one of gangland's celebrated 'one-way' rides," and the jumpy nerves began again.

"All the 'boys' are scared over the Milam killing because it was apparently bungled just enough to make its solution perhaps possible, should the investigation be pushed with the proper zeal," the *Tribune* opined.

Milam's troubles seem to have begun in the heart of then-rural Florida, "in the midst of strawberry fields and green pastures" near Lakeland, Deitche writes. There stood the Paramount Club, for a time in the 1920s and '30s "the finest gaming establishment in Central Florida." The party was over for the Paramount

in late 1939, Deitche says, after the bullet-ridden body of Henry Hull, one of the club's associates, was found floating in the Hillsborough River.

Investigations failed to turn up any evidence, but the state attorney shut the club down, and some of its habitués scattered across Central Florida. Deitche says one of them transferred operations to the Flamingo Café in Orlando, a well-known spot on what's now East Colonial Drive that some said led a double life as a legitimate nightclub and a haven for gambling.

Milam moved to Orlando, too, where he had made his home for more than a decade before his death at forty-three. His funeral took place at the Church of God at Kuhl (now South Orange) and Muriel Avenues, the *Sentinel* reported in an obituary that noted he had belonged to the Orlando Elks Lodge, the Chamber of Commerce, the Junior Chamber of Commerce and was a lifetime member of the Orange County Sportsmen's Association.

Despite the reported jitters throughout gangland, no one was arrested in Milam's killing. No trace was ever found of the bloodstained dark blue or black Ford in which he took his last ride on a spring afternoon in Orlando.

Tuxedos at the Flamingo Café

Orlando historian Eve Bacon called it "the notorious Flamingo Café." In old newspaper ads, it's the Flamingo Club. But apparently the decor favored not tropical pink but red velvet. That's what adorned the gambling room—the reason the nightclub was "notorious."

In the imaginary cinema in my mind, the place looks a bit like Rick's place in the movie *Casablanca*. It's a glamorized image, but understandable given the few mysterious black-and-white photos that survive, coupled with descriptions published in 1957 by Henry Balch, than an *Orlando Sentinel* editor and apparently a Flamingo habitué.

"Saturday night and holidays the place really jumped…Men wore tuxedoes, the women their newest evening gowns and wraps," Balch wrote about the club's heyday from the late 1920s to the mid-1940s.

The Flamingo's founder, Sam Warren, had come to town in 1923, Balch wrote, and first opened a "beer parlor" downtown at 13 East Pine Street. Despite Prohibition, Warren did fine, keeping his customers happy "with bonded liquor brought in from the islands."

Those customers were "the top people in town," Balch declared. "The police and sheriff didn't bother him. Prohibition was as unpopular as the plague." Whether or not Balch exaggerated in the glow of memory, folks didn't call those days the Roaring Twenties for nothing.

Warren bought land on State Road 50, then the Cheney Highway (now East Colonial Drive), for $9,400, and built a soda fountain called the Orange Drop and later the Flamingo in 1928. The 1940 phone book lists its address as 3600 East Colonial, which means it was about where the Herndon Plaza shopping center sits now.

In the Flamingo's prime, this was outside Orlando's city limits, and the club was beyond police jurisdiction, leaving only the sheriff's department to make occasional raids on its gambling operation.

"It was complete with tuxedo-bedecked professional croupiers, roulette wheel spinners and hard-faced card dealers," Balch wrote. Other legitimate Flamingo attractions included cuisine by "Chef Manuel," whose specialties included chicken

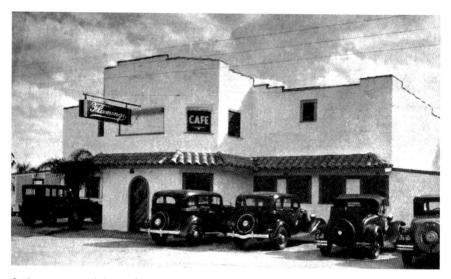

A vintage postcard shows Orlando's Flamingo Café, probably in the 1930s. A legitimate restaurant and nightclub, the club also is said to have harbored a popular gambling room in the back. *Florida Photographic Collection, State Archives.*

and yellow rice, bean soup, steak and hot Cuban bread, and there were entertainers such as "torch singer deluxe" Billie Fargo, known for her throaty rendition of "A Good Man Is Hard to Find."

One longtime Orlandoan told me the spot had a large legitimate restaurant and nightclub clientele; she never knew about the back room at the Flamingo, a spot frequented in those days mostly by men, as Balch told it.

Festooned with that red velvet hanging from the walls, and "the usual green felt covers on the dice and 21 tables," the back room had another fixture: "a white-haired, decent-faced old man whom everyone called The Colonel, behind the roulette wheel, shuffling chips," Balch wrote.

The usual procedure for most of the tuxedo-clad gents was to go to their dining room table in the front, order a drink and some food, dance once with their wives and then head for the gaming room. "It was nothing shocking," Balch maintained, "to see the mayor at the dice table."

I guess politics has always been a bit of a gamble.

The Good Times Rolled at Rosie's

"Oh, to be at Rosie O'Grady's," read the headline for a soldier's letter, sent home to Orlando from the Gulf War. By 1991, Rosie O'Grady's Good Time Emporium had become an Orlando institution, just what its founder, Bob Snow, had in mind when he started the retro Gilded Age music hall in 1974. For years, the good times at Rosie's rolled so vibrantly that folks assumed they would roll on forever. And as we tend to do with institutions, Central Floridians may have taken the old girl for granted—like the once-raucous, henna-haired great aunt you keep meaning to visit until the day you learn with a shock that she's slipped away in her sleep.

W e strive for quality, and to become an institution," Church Street Station's original founder Bob Snow said in the 1970s. "As an institution, you appreciate with age. We want to be the heart of the downtown area."

Snow's flagship establishment, Rosie O'Grady's Good Time Emporium, indeed became the engine that pulled downtown Orlando from its early '70s depths, bringing back both locals and tourists to streets Central Floridians had given up for dead after business hours.

Live or party downtown then? For most folks, not in a heartbeat. The action seemed to have all moved out to the area near Walt Disney World and other attractions that sprang up in its wake. Bob Snow changed all that. The Church Street Station entertainment complex expanded mightily during the '80s, with Rosie's as its cornerstone. Even after Snow sold the place and moved on to other adventures, it seemed as though Rosie's was as much a part of Orlando as the swans at Lake Eola.

Then the shock came on May 31, 2001, with the announcement that new owners of Church Street Station would close the north side of the downtown entertainment complex August 1 as part of a redevelopment plan still being formulated. The last shows at Rosie's would be in June, a few weeks short of the twenty-seventh anniversary of the club's opening on July 19, 1974.

"Since I've been here so long, I've often wondered how it would end," said Rosie's "Good-Time Ambassador" Rob Oke a few days before the finale. He had

opened the place in 1974 and he'd be there to see the old girl out. "Millions of people have come through those doors," he said in the hush between shows under Rosie's high, pressed-tin ceiling. "It's sad to see a legend close."

The crowds sure came opening night, Oke remembers. Make no mistake, Orlando had nightclubs in the summer of 1974. Gary "U.S." Bonds was at the "Where It's At" Lounge, Ross Raphael's Orchestra was playing at the Villa Nova and Barbara McNair opened at Disney's Top of the World club.

And there were more—Sheik's, Kilroy's, the Empire Room at the Langford, Limey Jim's near Walt Disney World. But no notable clubs were downtown, and certainly not on Church Street by the railroad tracks, an area Rosie's now-retired "Red Hot Mama" Ruth Crews recalls as "still kind of scary. There were boarded-up buildings. You had to be walked to your car."

It was "like Tombstone territory," agrees Spatz Donovan, who walked into Rosie's in 1975 and stayed to become a headliner there for fourteen years. In those early days, "you could practically see tumbleweeds rolling down the empty streets."

Bob Snow changed all that. "He opened to such adversity," remembers Terry Lamond, the original Red Hot Mama on opening night. "But we took the city by storm."

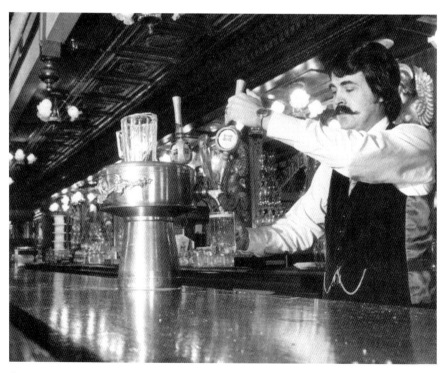

Church Street Station's founder Bob Snow draws a beer at Rosie O'Grady's Good Time Emporium in 1975, about a year after Rosie's opened. Snow decorated the place with authentic vintage fittings from all over the world, creating a Gilded Age extravaganza of wood, brass and glass. Orlando Sentinel *files*.

THE GOOD TIMES ROLLED AT ROSIE'S

In news pages sagging with Watergate and the rumblings of President Nixon's impeachment, Snow announced Rosie's in large ads festooned with Victorian wood type and old-timey banjo players. "Rosie O'Grady's is 75 years behind the times and proud of it," the ads proclaimed.

There were no mentions of "cocktails"—although the libations surely flowed. Rosie's was not a "lounge." Rosie's, Snow announced, was "Americana, Ma's apple pie, railroad cars and whistles in the night, handlebar mustaches, sleeve garters, straw hats and the Fourth of July!" People loved it. On opening night, "we were mobbed—there were lines going around the building," Bill Allred remembered in 2001. The top-notch jazzman had put Rosie's band together and led it for years.

"Everyone is so friendly," one patron told the *Sentinel* that opening night. "I remember the '20s, the '30s, the '40s," said another first-nighter, John Franz. "This place comes real close to what it was like, I'm tellin' you. I'm gonna come here all the time. I like the atmosphere." Another couple, George and Marsha Haberkern, loved both the "1890s decor and the loud and tumultuous atmosphere." It cost a dollar to get in.

Donovan remembers that when he whirled through the swinging saloon-style doors that were Rosie's main entrance in 1975, inside was a world of high-energy performance and laid-back fun. Rosie's had "so much flair, so much moxie, so much chutzpah," Donovan remembers. Everywhere you looked, something was happening—a Harpo Marx look-alike making goo-goo eyes at the ladies, a "Lou Costello" spinning his tray. And the band? "The band was just cooking," Donovan says.

Bandleader Allred described the big patriotic finale, with Uncle Sam on stilts, flags waving to the tune of "Yankee Doodle Dandy" and the Statue of Liberty—a woman tapped from the audience to promenade in with the entertainers around the packed room, carrying her torch.

The spirits got especially high on Rosie's Nickel Beer Nights on Wednesdays, when the place was packed. Former cancan dancer and waitress Sherry Lester was the secret weapon in the beer-chugging contests. "They'd put me last, up against some big, burly guy from the audience. There was one guy in those contests who would chug beer standing on his head," she recalls.

The mood was serious fun, and the music was seriously good. Lamond, a graduate of big-band days who had sung with the likes of Artie Shaw and Benny Goodman, remembers the excellent musical charts and arrangements—the quality that was Snow's trademark.

And the big room remained what Donovan calls a "feast for eyeballs."

Snow had haunted auctions of architectural antiques, filling the place with real vintage fittings from all over the world, cooked up into a Gilded Age extravaganza of wood, brass, glass and class that looked right at home in the old Slemons Department Store building, even though little of the decor was in the building until Snow put it there.

The four burnished brass chandeliers, each weighing eight hundred pounds, came from the former First National Bank building in Boston, Snow said on the day the place opened; the cut glass in the doors was the heaviest ever made in New Orleans. The sixty-five-foot bar was made of Honduran mahogany and the painted glass panels once graced an English pub. And on and on.

Snow, the man at the center of it all, was only thirty-two when the good times at Rosie's began. Many of the entertainers who worked for him still refer to him as Mr. Snow, even though they were years his senior.

And they all have stories, like the time Snow phoned Rosie's and told the band and cancan girls to meet him at the SunBank (now SunTrust) building down the street, with Rosie's trademark firetruck.

To the sounds of jazz and the bubbles of champagne poured by the dancers, Snow repaid a SunBank loan with $300,000 in cold cash, carried in an Old West–style saddlebag that he plunked down on the desk of a dumbstruck bank officer. That's what Donovan meant by "moxie."

That and the rest of it: the skywriting by Snow and his colleague Colonel Joe Kittinger—another Orlando legend. There were the huge hot air balloons, the bagpipers, the jugglers and lots more.

One visitor during Rosie's last days, Vance Kaupang of Winger, Minnesota, said he just wanted to cry to see so much of it gone. "Some of the best times I've ever had" were in there, the teacher remembered.

"Rosie's is timeless," Snow said not long before Rosie's closed. And "it was built with wonderful, enthusiastic, talented people." To succeed in the restaurant and entertainment business, he said, "You've got to know it, feel it, love it. You can't just like it. You've got to love it."

FROM SAND TO SPEEDWAY

Veteran journalist Ed Hinton has written that "properly translating motor racing for general readership is the most difficult sports-writing job there is." That's understandable, given that some of us general readers may wonder whether the dangerous combat on the asphalt oval is really a sport or a bit of madness. Nevertheless, motor racing and the Daytona International Speedway encompass a vital part of Central Florida's past, beginning with the quest for speed on the beach more than a century ago. And each February, thousands of Orlandoans have long headed east to the Daytona 500.

Drivers had plenty to be nervous about when they took to Big Bill France's spanking new 2.5-mile speedway for the first running of what's now the Daytona 500, the race that draws more people each year than the populations of most Florida cities, including Orlando. Lee Petty's twenty-one-year-old son, Richard, would later recall that when he came out of a tunnel under the fourth turn, "suddenly it was like being on the surface of the moon." Far in the distance, "you could see the high banking of the first and second turns…It looked like it must have been 30 miles down there to the banking." Even back then in 1959, the roaring crowd was more than 75,000; now it's usually more than 200,000.

The track had already grabbed the news spotlight that February. "Racing Champ Dies in Daytona Crash" blared front pages in Orlando on February 12, 1959, ten days before the big new race. Marshall Teague, a veteran of the beach-road course where France had long promoted races in Daytona, was on a test run in a streamlined Indianapolis-style race car when his vehicle "lifted, floated, flipped five times" and scattered as it went, killing Teague.

That description of the flipping and floating and the death that followed is by *Tribune* newspaper's veteran sportswriter Ed Hinton in his 2001 book, *Daytona: From the Birth of Speed to the Death of the Man in Black*. The last part of the subtitle refers to the death of Dale Earnhardt in the last turn of the last lap of the 2001 Daytona 500. In the early chapters, Hinton lays out the romance and drama of NASCAR's origins, beginning with the races on the sand at Ormond Beach more than a century ago and going through the early races on the old beach course.

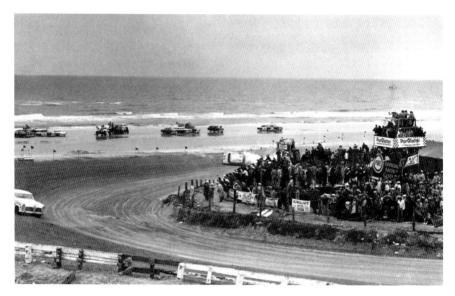

A crowd watches a race accident on the beach road oval in Daytona Beach in February 1956. On the beach track, "Big Bill" France once recalled that the best driver he ever saw was a young Georgian named Lloyd Seay, who would come through the north turn on only his right-side wheels. *Florida Photographic Collection, State Archives.*

On the beach, France would later recall, the best driver he ever saw was a young Georgian named Lloyd Seay, who would come through the north turn on only his right-side wheels, so that his car always looked as if it were going to turn over. "I've never seen anything like that, before or since," France said. But Seay died years before the premiere of France's big asphalt oval, shot through the heart when he was only twenty-one during a bootleggers' quarrel, Hinton writes. The sport that's now rich in corporate sponsorships bears a distinct outlaw edge to its heritage.

Among the sixty drivers who did qualify for that first 500, the Orlando area favorite was clearly Edward Glenn "Fireball" Roberts. The Florida native had been NASCAR's top money winner the previous season, with a take of $38,000. In 1959 he called Daytona Beach home, but he had grown up nearer to Orlando in Apopka, where he had picked up his nickname as a baseball pitcher in high school and American Legion baseball. In 1957, Roberts had been voted NASCAR's most popular driver.

"He has huge hands and a heavy foot that takes him in and out of troublesome situations neatly and safely," the *Orlando Sentinel*'s Henry Balch wrote in 1959.

On the day of the big race, Fireball took the lead after only twenty-two laps, but his car was weaker than his nerve. The finish came down to a duel between Lee Petty, father of Richard, and a less experienced driver named Johnny Beauchamp of Harlan, Iowa, who was pictured hugging the trophy in next-day news reports under a headline that read "Beauchamp Wins—But Title Disputed."

France and the flag official had called Beauchamp the winner by two feet, just as Petty drove down victory lane, declaring himself the winner by the same small distance. According to sportswriter Hinton, Lee Petty was an excellent driver, but what he did better than anyone was protest race results. He would do it again the next year in 1960, Hinton writes, at Atlanta's Lakewood Speedway, when he stomped up to officials to protest the victory of the "pearly-grinning youth" who had taken the checkered flag: his son, Richard.

And at Daytona in February 1959, after newspapers reported the Beauchamp win on Monday, by Wednesday late in the afternoon, Lee Arnold Petty of Level Cross, North Carolina, was declared the winner of the first "Grand National" stock car race at the big oval by the road that's become International Speedway Boulevard.

Diving into History at Daytona Beach

During Central Florida's punch-drunk hurricane season of 2004, the peaceful September weekend between Frances frenzy and Ivan anxiety offered a chance to see how favorite landmarks fared at Daytona Beach, about an hour's drive from Orlando. Before it became linked with stock-car races and motorcycles, the World's Most Famous Beach drew Orlandoans because of its prime spot next to Florida's original tourist attraction. The ocean is immense, exhilarating, even dangerous—but at the same time, many of us begin to drop our grip on stress and tension just at the sound of it. For decades, Orlandoans have ventured to the East Coast beaches to relax by the side of the big water that, ironically, not only calms us but cooks up these harrowing storms.

My Daytona of idealized memories is free from tattoo parlors and time-share salespeople, condo towers and coleslaw wrestling, huge hotels and Harley riders. In their place is a lost, sun-blasted world that smells vaguely of Coppertone and contains scenes of the long-gone Steak n Shake on Atlantic Avenue; of thick green lawns separating hot sand and cool motel walls; of rinsing that sand off your feet under an outdoor faucet that spurts sulfur-scented water.

The soundtrack to it all is the surf, the ceaseless ebb and flow of the waves. You can hear it even through the sturdy walls of one of the area's oldest motels, the Cabana Colony Cottages in Daytona Beach Shores. Nearby, the blowhard storms smashed souvenir shops on Atlantic Avenue and reduced them to shards of glass and gobs of soggy insulation. But the Cabana Colony's owners, the Molnar family, have restored the cottages so that hurricanes Charley and Frances bounced off the tight metal roofs of this survivor from the 1920s.

About the same time the cottages were constructed, what's now the Main Street Pier in Daytona Beach was taking shape several miles north, on the site of an earlier pier built in the late 1800s. Crafted of palm logs and wooden planks, that earlier pier was washed away by storms and replaced by the Pier and Beach Casino in 1925. Even after the one-two punch of hurricanes Charley and Frances, it's still there, the scene of music and dancing from the Charleston era to the Allman Brothers and beyond.

During the 1930s, other vintage beach landmarks joined the pier and casino. The coquina clock tower and bandshell at Daytona's Oceanfront Park were completed in

DIVING INTO HISTORY AT DAYTONA BEACH

1938, part of a Works Progress Administration project during the Great Depression. Both have weathered the years and the storms well, although the clock tower seems literally lost in time: Each of its four clock faces indicates a different hour. Its appeal springs not from functionality but from its Florida-deco styling, with the letters spelling DAYTONA BEACH circling around each clock face instead of numbers.

The Bandshell, once proclaimed the largest open-air theater in the United States, is now dwarfed by new buildings behind it. If you look out at the ocean, though, the vista remains unchanged, and the Bandshell still is the scene of many live performances. (See bandshell.org on the Web.)

Back toward the pier, in the last surviving remnant of old-style boardwalk at the beach, dwells the lady that holds the top spot on my storm survival checklist. She could well be the most photographed gal in Daytona Beach, even though she doesn't sport a bikini. And tattoos? Oh, please. Not for the Red Diving Girl, the nearly twenty-foot icon that has adorned Stamie's Swimwear shop at 8 North Ocean Avenue since the days when the Beatles were new.

In the summer of 2003, I had talked with the eponymous Stamie herself, then eighty-nine and still working in the shop that looked very much like it did in the 1960s.

Stamie Kypreos married her late husband, Theodore, in Orlando in 1935, the year Elvis Presley was born. A dozen years later, Harry Truman was America's president when Kypreos opened her shop on Ocean Avenue and began selling swimsuits to ladies and gents.

The "Red Diving Girl" sign found a home at Stamie's Swimwear in Daytona Beach in the mid-1960s. The fiberglass sign, which belongs to the Jantzen Company, is one of only six made by a Los Angeles mannequin company in 1959. *Photo by Joy Wallace Dickinson.*

"Some of my customers come by every year just to see if I'm still alive," she joked on a June Saturday, as she visited with a couple from Georgia who confirmed they indeed have been stopping by for years.

Kypreos paused to ask a shopper how she fared during a dressing-room session of trying on bathing suits. The scene is a classic of American retailing, especially in Florida, where swimwear and summer go together like grits and gravy. The customer was grappling with the reality that she has consumed a few too many grits, a little too much gravy during the winter, and she replied with a variation of the thought that the bathing suits are fine; it's the body she's trying to fit into them that's the problem.

How many thousands of times in more than fifty years must Kypreos have heard this kind of fretting. The pounds! The thighs! I'll never look like…Betty Grable, Marilyn Monroe, Audrey Hepburn, Twiggy, Cindy Crawford, Halle Berry and on and on. The beauty icons have changed, but the quest for the perfect bathing suit remains.

So does the big gal in the red suit outside, suspended in a perpetual, graceful swoop. This incarnation of her, owned by the Jantzen company of Portland, Oregon, is one of only three or so in the world, Kypreos said. One of the statue's sisters is suspended from the ceiling of the American Advertising Museum in Portland.

The Red Diving Girl symbol has been around for decades longer; she holds a high place in the history of both advertising and sport. In her day, she was considered a glamour gal as hot as Halle, as groovy as Grable.

In a saucy suit resembling a long tank top, the Diving Girl became something of a craze in the 1920s. In 1922, Jantzen printed ten thousand Red Diving Girl stickers that were distributed in store displays, which people grabbed up to paste on the windshields of their cars. Proper Massachusetts banned the decals from auto windshields.

By the 1930s, billboards featuring the work of artist George Petty and others had transformed the Diving Girl into a long-legged airbrushed dish. The "Petty Girl" became a popular pinup in the 1930s and 1940s and is said to have been the first centerfold, in *Esquire* magazine. She didn't have to worry about her weight, of course; she was an illustration.

In 1959, a mannequin company in Los Angeles transformed the Red Diving Girl, now in an elasticized strapless one-piece, into three dimensions and made six nineteen-foot fiberglass versions of her to be used on signs.

One of the six made its way to Miami and, in 1965, to a happy home at Stamie's by the World's Most Famous Beach. She has been there ever since, despite repairs from storm damage in 1980 and the day-to-day toll of humidity and salt air. Her once-white cap is now painted red to match her suit and dainty toenails. A girl must keep up with fashion, after all.

When Kypreos first opened the shop in the late 1940s, a two-story motel sat across the street, a tiny structure compared with the hotels going up around Stamie's. During my 2003 visit, a picture of the old motel sat on a shelf at Stamie's, next to a wall of family photos, including Theodore and Stamie

Kypreos at their 1935 wedding. Born on an island in the Aegean Sea, Theodore died in 1988 at eighty-two.

When the couple moved to Daytona Beach in the 1940s, "we used to have parties and picnics on the beach," Stamie Kypreos remembered.

Outside her shop after the storms of 2004, the Big Girl seems fine. Supported during the storms by a couple of ropes around her sleek shoulders and gams, she boasts a recent coat of bright red paint for her strapless suit and her matching nails. Caught in her perpetual dive, she flies through wind and time, smiling her own brand of Mona Lisa mystery, a guardian of the past by the great ocean that has brought us more than enough good times to make up for the rough ones.

SIGNS OF OUR TIMES

"It is sad but true to say that most of us take our surroundings for granted," begins a book called Words and Buildings *by British design expert Jock Kinneir. He's talking about architectural signs, the "no-man's-land between architecture and graphic design." It's true you've got to pass plenty of visual chaff on the roadways in the search for nuggets—those blinking, curving, glowing relics from the days when businesses expressed their individuality and appealed to customers through color and light. In the Orlando area, many of the great ones were designed by Bob Galler, the dean of Central Florida sign design, and their memory kept alive in recent years by graphic designer Rick Kilby and his brother, photographer James Kilby.*

When Orlandoans see that big red "Merita" from Interstate 4 after a trip to the west coast of Florida, we know we are home. Accompanied by the homey aroma of baking bread, the decades-old sign for the Merita Bakery welcomes us with the time and temperature, too.

The sign has become such a fixture that it seems part of the landscape now, but once it was just a rendering on a designer's drafting table—in this case, Bob Galler, who is now design vice-president of Orlando's Graphic Systems, Inc. That company's heritage goes back to 1938 and to Wallace Neon Manufacturing, owned by the family of Graphic Systems President Bob Wallace, who began his career there after college in 1960.

Galler, who graduated from high school in New Jersey in 1948, arrived in the Orlando area in 1950 to spend time with two uncles who were sign painters. When the uncles' employer learned their nephew could draw, Galler soon found himself sketching designs for signs at the start of a career that would leave his artistic imprint on Central Florida's collective memory.

Mention virtually any well-known area sign to Galler or Wallace and, even if they didn't do it, they can recall something about it or produce pictures of it from their scrapbooks. The long-gone Roper's sign, where a neon grill cook flipped burgers by the side of Orlando Avenue in Winter Park? Galler pulls out a picture of the fence behind the eatery. "There was neon all over that fence," he recalls, sparking memories of other signs that once blinked and flashed to depict movement.

The Beefy King sign at 424 North Bumby Avenue in Orlando, across from Colonial Plaza, has announced the family-run business since 1968. *Photo by Joy Wallace Dickinson.*

At a downtown Orlando corner, a neon suitcase opened and closed, Galler remembers. Patrice Howard, Wallace's daughter and another sign industry pro, recalls a favorite from childhood: a bathing-suit-clad neon lady who appeared to dive and make a splash into a swimming pool. That was at the Tour-O-Tel on Orange Blossom Trail, said to be Orlando's first real motel in the 1930s. (The neon diver came later.)

At Galler's sign for the Orlando Motor Lodge, long a fixture at 1825 North Mills Avenue near Lake Rowena, a large arch outlined in neon framed the entrance for visitors. That one was quite large, like his Merita Bread sign, which originally had a round clock with hands rather than a digital display, he remembers. It also originally said "bread & cake" instead of just "bread."

Like any artist, Galler hates to pick favorites among his designs, which include signs for the Imperial House and Harper's Tavern in Winter Park and McNamara Pontiac in Orlando—that one "all made out of porcelain," he says, like the original Holiday Inn signs.

The big Orlando star that hangs downtown during the Christmas season and the neon McCrory's sign that used to reside nearby it both are in his portfolio of memories, but there's one that was a special favorite, he admits: the swooping aqua banner for Ronnie's at the old Colonial Plaza, where Galler ate breakfast at least once a week.

The mechanism that made the Ronnie's sign light up in a sweep was about as big as a sizable conference table, Galler and Wallace remember. Now its synchronized display could be orchestrated by compact computerized controls.

If Ronnie's is gone, another of Galler's eatery signs remains nearby: Beefy King at 424 North Bumby Avenue in Orlando, across from the Plaza Theater (another grand old sign). People stop to see the Beefy King sign "all the time," Roland Smith said in 2002 about the roadside beacon that has announced his family's eatery since 1968. Most chain fast-food signs can't hold a candle to that steam-snorting steer, even though he no longer lights up at night and bears scars from Hurricane Charley in 2004.

"Type was a lot more fun" back in the 1950s and '60s, Orlando graphic designer Rick Kilby says about the Beefy King sign. "Look at how the letters bounce up and down. And that's just a great illustration."

Kilby has plenty of experience connecting history with typography and images. After earning his degree in the University of Florida's selective graphic design program in 1986, he worked for more than eight years for Church Street Station in Orlando, beginning his tenure under Church Street's founder, Bob Snow. Kilby used hand-rendered type to create the old-timey image that was part of the mystique of Rosie O'Grady's Good Time Emporium, Church Street's flagship enterprise.

For several years recently, Kilby produced a compact "Florida Roadside Retro" calendar, featuring photos of Central Florida vintage signs, many the work of photographer James Kilby, Rick's brother. Calendar images ranged from the Red Diving Girl and the Westchester Motel in Daytona Beach to the neon Stewart Jewelry sign in Orlando's College Park, along with Beefy King and Merita and more.

The brothers' work offers proof that, even more than other architectural landmarks, old signs can almost disappear before your eyes. It takes time to dismantle a building, but a sign can be gone overnight. Among the departed in Kilby's calendars are the monster citrus fruit that used to adorn Lee Road in Winter Park and the Gary's Duck Inn sign from the landmark restaurant that closed in 1994.

The oversize oranges are probably gone forever, but when the Gary's sign was taken down, it was stored in the collection of the Morse Museum of American Art, the legacy of the late Central Florida artists and art patrons Jeannette and Hugh McKean.

Jeanette Genius McKean, who founded the Winter Park museum, and Hugh, her husband and its longtime guiding spirit, are well known as champions and saviors of the art of Louis Comfort Tiffany, a cause they espoused long before Tiffany's stained-glass masterpieces became fashionable again in the 1970s.

In its warehoused collections, the Morse has more than forty vintage signs of significance to Central Florida, many of them from much-missed locally owned businesses along Park Avenue that have given way to brand-name stores. They even have one of the signs from Ronnie's.

If these beacons can't still be glowing by the roadside, perhaps saving and restoring them is a hopeful indicator that we may be realizing what we are losing as the old lights go out forever.

"In Central Florida, if something is ten years old, so often it gets torn down or renovated," Rick Kilby says. These signs are "a link to our past."

GETTING ARTY IN WINTER PARK

"The first art festival was off and running with a $25 donation from Darwin Nichols," *begins the late Elizabeth Bradley Bentley's history of the Winter Park Sidewalk Art Festival.* *If you need confirmation of old maxims about mighty oaks growing from tiny acorns, the story* *of the festival fits the bill: that $25 start in 1960 has bloomed into one of the most prestigious* *art shows in the country.*

It's turned into a quarter of a million dollar project," longtime festival supporter Ron Acker says on a Saturday morning before the Winter Park Sidewalk Art Festival, as he and fellow volunteers Lois Payne and Bob Klettner talk up the event to patrons of the Winter Park Farmers Market. The three are part of the festival's forty-five-member volunteer committee, which works all year, aided during the three days of the festival by many more volunteers.

"Our mission has always been to do world-class art—and real art," Acker says.

The folks who got the ball rolling at the end of the 1950s were inspired by the art being crafted from paint and canvas, clay and glazes and more, right in the environs of Park Avenue, Winter Park's main street. Robert Anderson, one of the quartet pictured in Bentley's book as founders of the festival, shared a studio with William Orr, another young painter, in a wooden building nestled behind shops at the northern end of the Park Avenue business district.

In the late 1950s, I was an art-struck preteen who ventured to that building on Saturdays with two chums for sketching lessons with Orr. To us, Anderson was a larger-than-life figure: a big man with a prosthetic leg, the result of a war injury, on display when he wore Bermuda shorts in the Florida heat. He also sported a small beard that looked much more Greenwich Village than Central Florida.

We didn't know it at the time, but Anderson had old ties to Florida: His grandfather, a lawyer and a judge also named Robert Anderson, came to the state in the 1800s and was instrumental in founding the Florida Bar Association. There's a nice portrait of him in Tallahassee.

To our young eyes, Anderson and Orr spelled artist with a capital A. And we weren't wrong. Both of them were fine painters, and Orr was a superb teacher who treated us like serious students, not kids. Orr still has a home and studio in Central

Darwin Nichols's Barbizon Restaurant on Park Avenue in Winter Park, seen here in the early 1960s, was the spot where the Winter Park Sidewalk Art Festival began. Orlando Sentinel *files.*

Florida, but Anderson left the area years ago, and in 2004 was happily living in West Virginia with his wife, June. Another of the four founders, Jean Oliphant, who died in 1990 at eighty-one, remained the central force behind the festival and its guiding light for many years, according to many accounts.

And what of the founder who put up the first twenty-five dollars, the seed money that has blossomed into many thousands? Reached by phone in 2004 at his home in New Smyrna Beach as he was helping some visitors from Maine thaw out, Darwin Nichols is going strong.

"I'm seventy-eight but I feel fifty-two," he says with a laugh. Now he is an accomplished painter of watercolors and acrylics who is warming up for a show next spring at the Art League of Daytona Beach. At the time he helped launch the Winter Park art show, Nichols was a restaurateur (he did pottery, too) and the owner of an eatery at Park and Canton Avenues.

For a long time the restaurant on that corner of Winter Park was the Beef and Bottle, but before that, when Nichols bought it in 1957, it was the Barbizon. There, according to Bentley's book, the Winter Park Sidewalk Art Festival got its start in 1960.

"I got interested because I showed people's paintings in the restaurant," Nichols recalls. Local artists would hang their stuff in the Barbizon, and patrons would buy the paintings right off the wall.

It sounds like those early years were a lot of fun. The folks who worked at the restaurant would stay up half the night making sandwiches and some of the artists' mothers would cook a ham or a turkey for festival-goers to share during a meal in the park. Then, the show was truly a sidewalk scene, lining both sides of Park Avenue from Fairbanks all the way to Canton Avenue and the Barbizon.

"The very first year the public got to vote on the most popular piece," recalls James "Gerry" Shepp, director of the Maitland Art Center and a past president of the Winter Park show. The winner was Arnold Hicks of DeLand, who won forty dollars; second prize of twenty-five dollars went to Jean Lowe of Orlando. With help from donations, the first festival managed to stay solvent, turning a symbolic profit of a nickel, which was kept for a time in a place of honor at Nichols's restaurant, the Barbizon.

More than four decades later, the festival's top award was $10,000, the apex of $60,000 in prize money that helps attract nationwide applicants to an art event that draws an estimated 350,000 people.

Carving His Own Destiny

Out on America's Great Plains each Sunday morning at St. Cecilia's Cathedral in Omaha, parishioners gaze at the thirteen-foot figure of Christ that Albin Polasek created for their place of worship during the early 1940s. The cathedral is one of many places around the world enriched by the career of Polasek, who died in 1965 after making his last home in Winter Park. There, in his lakeside home and studio, the Albin Polasek Museum & Sculpture Gardens continues to showcase the legacy of this son of the faraway Carpathian Mountains who carved an international career as a sculptor and teacher.

Not long ago, Albin Polasek was inducted into the Florida Artists Hall of Fame, the state's most prestigious cultural honor. (Also honored the same year were the late Alfred Hair and the other Florida painters from the Fort Pierce area known as the Highwaymen.) With more than thirty-five members who include both lifelong Floridians and folks who lived a number of years here, usually in retirement, this hall of fame speaks to the state's cultural diversity.

It's great fun to imagine what it would be like to gather these hall of famers for an artists' soiree. Literary icons Tennessee Williams and Ernest Hemingway could mingle in its ranks with homegrown voices such as the late folk singer Gamble Rogers. Broadway legend George Abbott could clink margarita glasses with the king of the Parrotheads, Jimmy Buffett. Polasek might tell them about his boyhood in Moravia, now in the Czech Republic.

The seventh son of a weaver and innkeeper, Polasek was born in 1879 in a small town at the foot of Mount Radhost, a legendary seat of gods and myths in Czech literature. His childhood was rich only in drudgery, one biography says. From an early age, the future artist walked with a limp, the result of a childhood accident. His father died when Polasek was nine, and the brothers struggled to care for the inn and the family's farm.

As a boy, Polasek didn't care for school, but he excelled at painting and carving Nativity figures and eventually became a journeyman in a woodcarving shop. In October 1901, when he was twenty-two, he and his brother Robert journeyed to Hamburg, where they boarded a steamer bound for New York City. After eight days, he wrote later, the metropolis looked as if it had risen out of the sea, a city of "millions of lights glittering on the surface of the bay."

Albin Polasek sculpted more than four hundred works of art in his career, including his signature piece, *Man Carving His Own Destiny*. His Winter Park home, which he bought in 1949, now serves as a museum and is on the National Register of Historic Places. *Albin Polasek Museum & Sculpture Gardens, Winter Park.*

In the United States, the young Polasek spent several years as a woodcarver, including a stint in an altar factory in La Crosse, Wisconsin, before he gained admittance to the Pennsylvania Academy of the Fine Arts in Philadelphia. After studies there and in Rome and Greece, he began his own studio in New York.

The greatest part of Polasek's career, though, was spent in Chicago, where he directed the Department of Sculpture at the Art Institute from 1916 until 1943

and continued an active career as a sculptor as well as a teacher. Hitler's invasion of his native Czechoslovakia had smashed his dreams of eventually returning to his homeland, and in 1949 Polasek purchased property on Lake Osceola in Winter Park. Today the home he built there is on the National Register of Historic Places. He died in 1965, in a world vastly different from the little town in Moravia where he had once driven cattle through the streets.

In his lifetime, Polasek created more than four hundred works of art, many of which are on display in Winter Park and at the Albin Polasek Museum & Sculpture Gardens (see polasek.org). One of Polasek's most famous subjects, *Man Carving His Own Destiny*, is at the Winter Park Public Library.

"I am like a piece of rock which has been broken off of the Carpathian Mountains in the heart of Czechoslovakia," he once wrote. "Later this crude stone was transported to the Land of the Free, the United States of America…Through the opportunities that this country gave me, I started to carve out my destiny, to free myself from the rock so that I might be useful…So if, as an immigrant, I have been able to contribute some small part of American life, I know that I owe it to the opportunities this country opened to me."

THE COWBOY SCULPTOR

One of the most significant artists to come from the Orlando area died in December 1955, in the tiny east Orange County community of Christmas where he had been born. Hughlette "Tex" Wheeler had wandered far and lived in the West for years, living where his commissions took him. Reference works on American artists list him as a California sculptor, but his cowboy roots ran deep in the sand of Florida. He is buried in Christmas, where his mother was born and buried along with "many of his family dating back to the Civil War era," Mary Ida Shearhart wrote in 2005 about her uncle Hughlette.

Born in east Orange County in 1901, Hughlette "Tex" Wheeler knew how to breathe life into clay, plaster and bronze, especially when it came to horses. His life-size monument to the people's champion, Seabiscuit, was unveiled in 1941 at Santa Anita in Arcadia, California, with the great horse himself present. Also at Santa Anita is Wheeler's statue of jockey George "The Iceman" Woolf, who rode Seabiscuit to victory in the famous 1938 match race against War Admiral. Along with Wheeler's tribute to the American folk humorist Will Rogers at Claremore, Oklahoma, the two sculptures at Santa Anita remain Wheeler's most visible legacy in bronze.

The sculptor's only child, Betty Wheeler Bass of Osceola County, Florida, was born on Rogers's Pacific Palisades ranch and named for his wife, Betty Blake Rogers. "I used to just watch in awe," Bass has said, recalling childhood memories of her dad at work. "I didn't know anybody could do that."

That's probably the way Wheeler's parents, James and Nora Ida Wheeler, felt, too. According to family legend, Ida Wheeler used to run her hot iron over a block of beeswax while she was using it to smooth the wrinkles from clean laundry. When her son Hughlette was a boy, he took a piece of the soft wax and formed it into the shape of a pony, an excellent likeness.

"That's a true story about the beeswax. That's when they knew he had talent," Shearhart, a historian of pioneer Central Florida, told an interviewer in 1999.

Wheeler grew up tending cattle on the palmetto prairies of Orange and Osceola Counties. "He was a real Florida cowboy," Bass says of her dad. "He loved that kind of life." But Wheeler's family knew his ability to carve bone or mold clay into

Hughlette "Tex" Wheeler, the cowboy sculptor from Christmas, Florida, with his life-size statue of Seabiscuit at Santa Anita Park in Arcadia, California. *Courtesy of Richard Lewellyn.*

incredibly good likenesses of animals, especially horses, was something special. In the early 1920s, a cousin of his father's from Ohio offered him room and board so that he could study at the Cleveland School for the Arts, and an aunt paid his tuition.

Either there or during a subsequent stint of art study in Paris, Wheeler gained the nickname "Tex," an ironic reminder that most folks don't realize Florida is old cattle country (probably the nation's oldest, dating back to herds brought from Spain in the 1500s). Because our western neighbors provided the scenery in so many Saturday-matinee movies, Wheeler's friends gave him a western moniker.

His real name, Hughlette, may have been in honor of the doctor who delivered him, William Leland Hughlett. According to stories passed down in the doctor's family, he practiced medicine in the Cocoa, Florida, area and surrounding counties from 1884 until his death in 1927, and he had delivered the Wheeler baby, who was named for him.

However Wheeler came by the name Hughlette—which is how his Florida relatives refer to him—the nickname "Tex" stuck in his distinguished career as a sculptor. It was a career not adequately appreciated, Willard Porter wrote in *The Western Horseman* magazine more than a decade after Wheeler's death in 1955.

"Hughlette Wheeler, the cowboy-sculptor from the Sunshine State, was a genius," Porter wrote.

"Without reservation, he was great and he got great likenesses," horseman Melville Haskell told Porter. "He had the extraordinary talent of catching the perfect likeness of an animal."

Wheeler's method seems to have been a combination of careful craft and inspiration. Through a lifetime of commissions to sculpt likenesses of racehorses, hunters, jumpers, cow horses, polo ponies and other animals, he saw each one as an individual and backed up his uncanny powers of observation with meticulous measurements.

Richard Llewellyn of Christmas, Wheeler's cousin, saw the sculptor's methods firsthand. "When I was sixteen, I went out to California and worked with him," Llewellyn recalled in 2003. Among Llewellyn's memorabilia is a postcard bearing Wheeler's notes on the back: a sketch of a horse's head in profile and straight-on, with measurements carefully recorded in inches: "Nose 4½" and so on.

That was late in Wheeler's life, when he was battling severe arthritis and other health problems. Years before, in 1929, he exuded youthful charm when he returned to Central Florida for a short stay and was profiled by an enthusiastic Elizabeth Robinson in the *Orlando Reporter-Star*. The cowboy sculptor had wowed them up north, she said. Besides doing well in art school, he was going great guns modeling the polo ponies of wealthy Cleveland folks such as Perry Firestone.

"He is older, more attractive, and possessed of a poise and maturity that have come with success and hard work. But in spite of his fine city clothes and his success, he refuses to give up certain old qualities that make him Hughlette Wheeler," Robinson wrote.

"All those highfalutin words about art and everything aren't me," Wheeler told her. "I don't know about anything but just these old cowboys and 'hosses' and ponies, and that's what I love."

It was said that Wheeler would not portray an animal he didn't like, and that he could size up a horse's personality in the first rough draft in clay. Perhaps that's why he was the perfect sculptor to memorialize "The Biscuit," a horse that some folks said looked more like a cow pony than a proper racehorse should.

Yet the horse that Laura Hillenbrand's book *Seabiscuit* describes as a "smallish mud-colored animal with forelegs that didn't straighten out all the way" became "one of history's most extraordinary athletes…graced with blistering speed, tactical versatility and indomitable will." Seabiscuit was the perfect champion for his hard-luck times: a working man's hero with a great heart.

The Depression years, when Seabiscuit gave Americans a hero they needed, may have robbed Central Florida of a more visible reminder of Wheeler. In 1927, there was talk of a Wheeler statue for Orlando's Lake Eola Park, but about that time the 1920s land boom began to go bust in Florida, well before the stock market crash of 1929. The city scrambled to finish schools and other buildings. Money for art would have to wait.

It would be some years before Wheeler returned to his Central Florida home, worn from battles with painful rheumatoid arthritis that began in the 1940s and from the alcohol to which he turned for relief, his niece Shearhart has written.

He called his last studio the Boar's Nest. The roof is mostly gone, but in 2003 the big stone fireplace remained, tucked under tall pines in Christmas, Florida, where a "Cowboy Reunion" still takes place each year at Fort Christmas Historical Park. A true Florida cowman, Wheeler hoped "to show people all over the world how interesting and picturesque cowboys and ranches and the range are," he said as a young man. "I would like my work to stand for something all American."

The Heart of Orlando High

"Orange and white, fight fight," students at Orlando's William R. Boone High School cheered at games in the 1960s, most not having a clue that those colors and the school's name were a direct link to the old Orlando High School, which had ceased to exist only a few years earlier. Nor did we have any idea, in our teenage self-absorption, of the high regard in which our school's namesake was held by his students or the sadness of his loss.

During their senior year, Orlando High School's class of 1952 was steeped in a sense of history. They would be the last: the last class of a school begun in 1927, the last OHS Tigers, big cats who had taken on the big towns—Jacksonville, Miami—in sports and academics.

After thirty-five years, Orlando High would be no more. Its students would be divided between two new schools, in the north and south parts of town. Its building would become a junior high. An era was ending in Orlando.

But how completely it was ending, no one could have known. For on Friday, June 6, 1952, the last day of the last term at the school he had led for twenty years, Principal William R. Boone was stricken with a fatal heart attack in the blond-brick school on East Robinson Street. As a teacher, coach or principal, he had not missed a day of school in thirty-five years.

At noon that Friday, Boone's school would officially cease to exist, retired teacher Ed Creech said in 2002, not long after the class of '52's fiftieth anniversary gathering. Creech and his colleagues called Boone "the boss": if the brick building had made a home for Orlando High, Boone stood at its heart.

It was a big school—more than 1,200 students—so the halls were unusually quiet that Friday, with only teachers at their desks for their final day of work. Graduation had been Monday night. Boone had handed out the diplomas to the class of more than 450 at an outdoor ceremony at the Tangerine Bowl.

Many of his former students did not hear of his death until they picked up the next morning's newspaper. "Orlando Senior High School died yesterday and its most beloved teacher died with it as thousands mourned," the story began. "When the school shut down, so did he," Creech said.

Revered Principal William R. Boone had not missed a day of school in thirty-five years when he was stricken with a fatal heart attack on June 6, 1952, the last day of Orlando High School's existence. *Research Center, Orange County Regional History Center.*

With the wisdom that comes with fifty years of living, class members at their fiftieth reunion found themselves looking back not so much on high-school hijinks as on the gifts Boone and other teachers had given them.

"What a fantastic principal he was," said class member Terry Owens. At the reunion, Owens told his Principal Boone story: how "in fear and trembling," he had been summoned to Boone's office early in his senior year. Owens, who went on to teach music in Orange County schools for thirty years, had carefully planned his class schedule so that he would have two free periods to spend working on projects for his passion, the school band.

"Mr. Boone had a low, booming, vibrating voice," Owens recalled. "Terry," he said, "I see you have two free periods in your schedule. No one has two free periods in my school. You'll be taking typing with Mrs. Hudson third period."

And that was that. For Orlando High was indeed William R. Boone's school. He had hundreds of students to look out for, but they all mattered—no one was off the radar screen.

Like other leaders of American schools in the mid-twentieth century, Boone had been born in the century before, on January 20, 1891, in Illinois. He had gone to

elementary school in Wellsville, Kansas, and had graduated from the University of Oregon in 1915. He went on to lead Orlando High during the Franklin Roosevelt years, but the era of his boyhood reflected the spirit of another Roosevelt—the unstoppable Theodore, a man of intellect and ceaseless energy, the kind of leader who could inspire others to become leaders as well.

"'Tis education forms the common mind; Just as the twig is bent, the tree's inclined," reads a quote from Alexander Pope that prefaces an old OHS rule book. It's likely the quote and many of the book's forty-one rules came straight from Boone's pen.

"It is called to the attention of all students that marking, cutting, writing on, or…disfiguring public property is in poor taste," reads Rule 26. "As a group we should seek to develop a pride in our public buildings, affairs and properties."

One private building near the campus that had special allure for students was Burton's, the venerable neighborhood bar and grill that still survives. "Since they served beer, it was quasi-forbidden, making it all the more alluring," Dr. Allen Holcomb, the student council president in 1952, recalls.

Jack Caldwell, the '52 class president, remembers accompanying Boone on an errand when the principal suddenly said, "Let's check out Burton's." When Boone suddenly appeared at the back door, students fled out the front, Caldwell remembers. "That should clear it out for a couple of weeks," Boone said.

"I don't know that we actually feared him, but we darn sure respected him," said '52 class member Gary Patterson, who went on to be an Air Force colonel.

What seems to have impressed the class members most were the personal touches: the card Boone typed himself congratulating Claude Hunter on an award bestowed on Hunter at graduation, the letters of recommendation, the personal notes. His last official communication was a thank you note he typed the day before his death, for a suit male faculty members had chipped in to give him.

"I only wish that I could have it to wear today," he wrote, "but they said it wouldn't be ready to don until Tuesday. That was tremendous to me—to receive this final token from the faculty and the wonderful note from many that accompanied it."

The following Monday, Boone was laid to rest in the suit, and the timing of his death echoes down the years for his final class.

During their senior year, Holcomb and others had petitioned the school board to name the new south high school after Boone, who was to become its first principal. (It did become William R. Boone High; the north school is Edgewater.)

"We were informed that there was an ironclad rule not to name any school after someone still alive," Holcomb said. A school staff member told Holcomb that Boone had been honored by their efforts, and had said that, though he would be pleased to have a school named after him, "he wasn't going to die for it."

"Spoken in jest, of course," Holcomb said. "But, it was an emotional moment when my mother called me at work" to break the news of Boone's death. After fifty years, "the irony of that event left me with a sense of wonderment that has remained with me since," he said.

Storyteller with a Camera

In 1963, E.B. Mitchell became the first African American news staff member in the history of the Orlando Sentinel. *Years earlier, he had opened his private photographic studio on Division Avenue, a street name symbolic to many black Orlandoans of the line between the worlds of black and white during segregation. Through his images, Mitchell became the chronicler of Orlando's black community.*

Around and west of Division Avenue, Edgar Bradley Mitchell was the person to see to have your photo taken. "Everybody wanted him to take their picture," said Deborah Murphy of the Central Florida Society of Afro-American Heritage, in 1988 after Mitchell's death. "He was the photographer in terms of documenting black history."

Many of Mitchell's images now reside in the collections of the Wells' Built Museum of African American History and Culture, said museum director Geraldine Thompson. Pictures of and by Mitchell are also included in Thompson's 2003 book *Orlando, Florida*, a photo history of the city's black community.

Weddings, proms, lodge meetings—you name it—E.B. Mitchell was there with his camera. "Any time they had a big game, you saw him on the sidelines taking pictures," his brother Thomas said in 1988.

"I can imagine he had to stomach a lot" in his time, Mitchell's niece Vicki-Elaine Felder said in 2005 about her uncle's role as a trailblazer during segregation.

"He was a very good photographer, always on the money," said Felder, a longtime Orange County high school teacher. "He was the Gordon Parks of Orlando," she said, referring to the photojournalist who was the first black photographer at *Life* magazine in the 1940s. Like Parks, Mitchell took "pictures that told a story."

The uncle Felder calls "Edgar B." grew up in the 1920s in a family of four children. Their father was a minister in the African Methodist Episcopal Church, and the family moved every two years because of his pastoral assignments. They came to Orlando in the 1930s, said Mitchell's sister, Anne Felder, a retired Orange County educator.

Mitchell's road to photography began in 1935 when, at eighteen, he joined the navy and bought a $1.98 camera to record his travels. What he found on the journey was his life's work. He fell in love with cameras and took workshops in

Edgar Bradley Mitchell, seen in 1963, made his mark on Orlando's history both for his private studio work and as the first African American employee in the *Orlando Sentinel* newsroom. "A piece of Orlando's black history dies with photographer E.B. Mitchell," a headline read when Mitchell died at seventy in 1988. Orlando Sentinel *files.*

photography after his navy service, eventually opening the Division Avenue studio with topnotch equipment.

After he joined the *Sentinel*'s staff, Mitchell first took photos for the paper's "Negro Edition," printed on tinted newsprint like its regional editions. Longtime Orlandoans often call it the pink section or the pink sheets. The edition was discontinued in the late 1960s, and Mitchell began taking pictures for the main newspaper.

When in the 1970s severe tornadoes struck the Orlando area, Mitchell grabbed his camera and rushed to document the storms, only to discover on his return that his own home had been badly damaged, Vicki-Elaine Felder said.

Despite the unsettling events of nature and society, Mitchell sounds like a man who knew how to make the best of life. Anne Felder, almost ninety in 2005, remembers "her sweet brother" as unfailingly "poised and courteous…He had that caring way about him." At his death, former newsroom colleagues too remembered a man of charm, humor and photographic expertise.

Once Mitchell gave a workshop to help *Sentinel* photographers achieve better skin tones in their pictures of people of color, one former colleague remembered. "I admired him for doing what he did," *Sentinel* photojournalist Richard Shepherd said in 1988. "He had to go places where he really wasn't wanted or accepted well." That included area golf courses, for Mitchell came to love golf almost as much as he liked taking pictures.

Thanks to collections of museums such as the Wells' Built, the stories Mitchell told through his photos—the big games, the wedding cakes, the golf matches and much more—won't be forgotten. "He was a fine photographer, a fine human being and—without knowing it, perhaps—a great historian," former *Sentinel* managing editor Bill Dunn said at Mitchell's death.

UNDERSTANDING ELVIS

Lifelong Orlandoan Jean Yothers retired after two careers, twenty-two years as a reporter and columnist and ten more as curator of the Orange County Historical Museum, now transformed into the Orange County Regional History Center. In 1955, when women reporters in Florida were as rare as snowflakes, Yothers described a young Elvis Presley's Orlando performances; the next year, she got an interview. Her many readers knew her intelligence and wit were something special, but in hindsight her abilities seem even more remarkable. In days when it was common for the press to deride "Elvis the Pelvis" as a hillbilly joke, Yothers recorded a remarkable talent and glimpsed the dangers the avalanche of stardom might bring.

Was he really good-looking?" you can't help asking retired Orlando newswoman Jean Yothers. After all, she not only interviewed him back in 1956, but she talked to him up close—got kissed by him, for goodness sake.

She doesn't say yes or no. "Sensual" is the word she uses about the twenty-one-year-old Elvis Presley. "He had those droopy eyelids," she remembers, "and he did have a way of looking right through you."

Then the unknown young man from Memphis, just a couple years out of high school, was causing shock waves in the '50s. Central Florida was no exception.

First, there were his clothes. On the front of the August 9, 1956 *Orlando Sentinel*, Yothers described the bright green sport coat, black trousers and white shoes that adorned the hip-shaking sensation the press had christened "the Pelvis," a name he detested. Youthful expression in dress was about to take off in colorful and rebellious directions, and Elvis, who had invented his own flamboyant style as a teenager, had more than a little to do with it.

More importantly, there was the music. Along with Scotty Moore on guitar and Bill Black on bass, Elvis in his 1955 Orlando debut had followed a long lineup of Grand Ole Opry stars such as Ferlin Huskey and Marty Robbins, as well as the young "hillbilly" comedian Andy Griffith, who had made a splash on television variety shows.

Presley may have been at the bottom of the bill, but Yothers knew she was seeing something special—"absolutely fantastic," she recalled years later. Her 1955 reports about Elvis in Orlando earned her a place in Peter Guralnick's *Last Train to Memphis*, the first part of his award-winning two-volume biography of Presley.

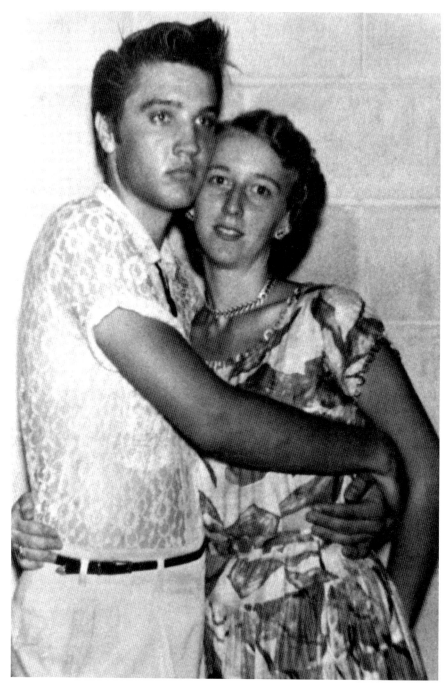

Fan Ardys Bell gets a hug from Elvis Presley in February 1956 in Jacksonville, where the first riot at an Elvis concert had happened the year before. When an unknown Presley had played Orlando in 1955, "the crowd went absolutely wild," reporter Jean Yothers wrote. "You knew this was somebody we should recognize as an up-and-coming star." *Florida Photographic Collection, State Archives.*

At one show, Faron Young "was real sharp singing that ditty about living fast, loving hard, dying young and leaving a beautiful memory," Yothers wrote, "but what really stole the show was this 20-year-old sensation, Elvis Presley, a real sex box as far as the teenage girls are concerned." She had spoken with him before the show and found him "a swell guy," she wrote in her "On the Town" column.

"Colonel" Tom Parker, who began representing Presley only a few days before the Orlando tour stop, had organized the show, and he knew what he was doing in putting his new boy on last. When "Elvis, Scotty and Bill" finished off the evening, Yothers says, "the crowd went absolutely wild…You knew this was somebody we should recognize as an up-and-coming star."

In the year following, during his Florida concerts—especially one in Jacksonville in which several hundred fans had stormed the backstage area—Elvis Presley was transformed into a national sensation. Jacksonville promoter Mae Axton recalled for Guralnick a memory of the twenty-year-old Presley, who had scrambled to the top of a shower stall, looking "sheepish and scared" as fans tore his shirt and his coat to pieces. It was after, Guralnick writes, that Parker really got dollar signs in his eyes.

When Presley returned to Orlando in August 1956, his legendary Ed Sullivan Show appearances were still in the future, beginning about a month after his Orlando show. But in the year since Yothers had first seen him, he had created a sensation on TV shows hosted by Milton Berle, Tommy Dorsey and Steve Allen. Now he was front-page news. "Wiggling Elvis to Play Orlando Twice Today," reads a headline for August 8, 1956. Yothers and a news photographer elbowed their way backstage after one of two packed performances at a sweltering Municipal Auditorium to interview the country's leading sensation.

Her clearest memory? The sensual eyelids, yes, but more important, "a real nice kid," still near the beginning of his transformation from a music-crazy Memphis boy into a social phenomenon. And what about that kiss? "I egged him on," Yothers remembers. News reports were full of stories that he always kissed women reporters who interviewed him, she says, and she asked him if that were true and got the desired result. Then she got the photographer to capture a repeat kiss and swooned appropriately for the camera. And, yes, she still has the picture.

It was a heady time for a star on the rise, but even a year earlier Yothers had worried about the price of pleasing those screaming, clothes-tearing crowds. "I think Elvis is pushing himself too fast," she had written in July 1955. "He's wearing himself out giving the customers more than their money's worth. I just wanted to say to him, 'Slow down, boy…your fame won't disappear,' but he still goes like a house afire."

Decades later, the fame indeed has not disappeared, but the nice young man with the Southern manners who kissed her cheek is long gone, dead at forty-two before the 1970s ended, perhaps exhausted by the pace of simply being Elvis.

THE CAT FROM CLOUDLAND

Remember Alice tumbling down the rabbit hole to Wonderland? Curiouser and curiouser. My path to a kind of Alice-like alternate reality winds through a microfilm reader, where reels of old Orlando Sentinel *newspapers offer transport back in time. And when I'm reeling and rocking through the 1950s, even if my research topic is ponderous, columnist Clyde Sanders is there for a reading treat.*

It's hard to stay on course during my research time trips through old newspaper microfilm. There's always some diversion rolling by. I'll be on a quest to find something, say, about the Central Florida Fair, and there gliding by on the microfilm reader will be a pearl like this front-page article from February 23, 1957:

"Wild dungaree-clad teenagers by the thousands stormed the Paramount Theater" in New York for a rock 'n' roll show. "They smashed glass and danced barefoot in the aisles and their ecstatic screams drowned out the savage beat of the music that held them in sway." That Associated Press report shows just how dangerous and crazy that old-time rock 'n' roll was considered in the 1950s, especially because of its roots in black rhythm and blues.

In the Orlando area, teenagers were lucky to have "Clyde on a Cloud" to assist their musical education. From 10:00 p.m. to midnight on WLOF ("We Love Orlando Florida"), Clyde Sanders spun platters on the air in the late 1950s. In her book on the history of Orlando's black community, Geraldine Thompson says Sanders was the "first African American in the city to work as a radio announcer."

Jerry Fitzgerald of Winter Park, a 1956 graduate of Edgewater High, paid tribute to Sanders's radio persona several years ago in the *Sentinel*, in an essay titled "Cruisin' and Spinnin': We Were Cool in Orlando."

"Clyde on a Cloud blared from car radios at decibels just above the pain-level," Fitzgerald recalled, "as teenagers cruised Colonial Drive to the Pig n' Whistle Drive-In and to the Beachcomber Drive-In on Orange Blossom Trail."

Because of WLOF (950 on the AM dial) and Clyde on a Cloud, Fitzgerald wrote, white as well as black teenagers got an introduction to the "the great pioneers of rock 'n' roll such as Bo Diddley, Ruth Brown, Hank Ballard and the Midnighters,

Little Richard, Chuck Berry and Jimmy Reed" long before most of the rest of the white audiences ever heard of them.

While Sanders spun platters at night, he also spun a weekly column, "As Clyde Sees It," in the section dubbed "the Negro Edition" that the *Sentinel* produced for a time in the '50s and early '60s. Though his late-night radio shows are gone, Sanders's columns preserve samples of his patter in newsy community items laced with authentic cool-cat lingo.

"A fine wedding jumped down last Sunday," he wrote in February 1957. "The cat came all the way from England to get hitched to Miss Bernice Wilkes...Hope you two have the best of luck, M-Sgt. and Mrs. Marshall Gunishaw."

The next item reported that "Chester O'Neal is in town for a few days visiting his Mom and Pop. Take it slow, Cheet, before you are beat."

Other items were more mysterious, riffs on the foibles of human behavior by unnamed miscreants. "Some cat ran into the back of some little young cat out my way and wanted to talk loud," Sanders mused. "His car was as old as I am. What does he want? Egg in his beer or wood on his fire?"

"Cat" was without a doubt his signature word. "Peter Pan Bates walked back from Miami to show off a new pair of pants," he quipped in a 1957 column. "That cat was so gone he looked like he had never been here."

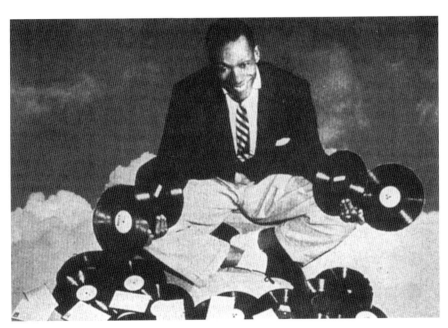

In 1950s Orlando, Clyde Sanders spun platters at night on his "Clyde on a Cloud" late-night radio show and wrote columns laced with hip lingo in the newspaper. He was the "first African American in the city to work as a radio announcer," Orlando historian Geraldine Thompson writes. *Wells' Built Museum of African American History and Culture.*

Imbedded in Sanders's columns are mentions of the musicians visiting the Central Florida clubs on what's been called the "chitlin' circuit" during segregation days. The Bossman of the Blues, Big Joe Turner, would be at Club Eaton in Eatonville that night, he reported February 22, 1960. In 1957, speaking of the legendary Louis Armstrong (but never mentioning the name), he riffed that "Satch, the old man with the fame, will be in town on the 27th with the same old jive the phone is ringing. Go and see him."

None of the venues Sanders noted in his columns holds more retrospective glamour than the South Street Casino, later called the Quarterback Club, that sat at 519 West South Street. Dr. William Monroe Wells owned the casino, which was damaged by fire and demolished in the 1980s. It sat next to the fine brick hotel he built in the 1920s so that black visitors to Orlando would have a place to stay. Now the Wells' Built Museum of African American History and Culture, of which Thompson is director, the former hotel building functions as a strong community anchor and force for preserving the area's heritage.

On February 29, 1960, Sanders announced a "Big Platter Hop" for teens at Washington Shores Elementary School. The younger kids could dance at 4:00 p.m. (fifteen cents admission), and high schoolers could come to a later party at 8:00 p.m. for only a quarter. "Cloud Boy," as Sanders referred to himself in one column, would be there to spin the platters, and I'll bet they were some good ones—maybe Ruth Brown, Jimmy Reed, Chuck Berry, Little Richard and Big Joe himself.

Across town we "dungaree-clad" white kids perhaps were supposed to be playing Perry Como and Mitch Miller. Not that there's anything wrong with those talented gents. But thanks to Clyde and his late-night radio show, all of Orlando could know that there was a lot more to great American music.

On the Road with Jack

For years Central Florida television journalist Bob Kealing has tracked stories of courts and crime for WESH-Channel 2, but in his spare time he long pursued a vagabond ghost, in a journey that culminated in his 2004 book, Kerouac in Florida: Where the Road Ends, *published by Central Florida's Arbiter Press. Kerouac died in Florida in 1969 at age forty-seven. Both lauded and reviled by critics in his lifetime, decades later he has never been bigger. The manuscript of Kerouac's* On the Road, *typed on a long roll of teletype paper, sold in 2001 for $2.4 million.*

Listen Joyce," Jack Kerouac wrote from Orlando to his girlfriend in New York City on a winter day in 1957. He had news: he was tearing along on a new novel, "greater than *On the Road.*" It would be called *The Dharma Bums,* and he described gazing up at the stars over Florida for inspiration about how to wrap it up.

Kerouac was doing his stargazing and his writing at 1418½ Clouser Avenue in Orlando, in the back of the College Park house that's now a city Historic Landmark and the focus of the nonprofit Kerouac Project of Orlando, dedicated to furthering the author's legacy in Central Florida.

On a Sunday afternoon in 2005, that legacy got a boost when the project's cofounder, Bob Kealing, arrived at the house bearing literary treasure: the final, 197-page draft manuscript of *The Dharma Bums,* which the project had just purchased from Kerouac's estate. As other Kerouac Project boosters gathered around the typescript to get a look, an ebullient Kealing regaled them with stories of his trip to Lowell, Massachusetts, where he wrapped up details of the purchase.

One of his listeners had seen the manuscript almost fifty years before, although he may not have realized it. After the publication of *On the Road* in 1957, Central Florida photographer Fred DeWitt had snapped images of Kerouac in the College Park house for *Time* magazine. In some of them, Kerouac is typing the final *Dharma Bums* manuscript from his draft typed on a continuous scroll of teletype paper, as he had written *On the Road.* For the princely price of $1.40, he had purchased "a roll of white teletype paper that reaches from Orlando, Fla., to New York City," he wrote his girlfriend Joyce that fall.

In one of Fred DeWitt's photos from early 1958, Jack Kerouac types a draft of *The Dharma Bums* at the College Park house that's now an Orlando Historic Landmark. Kerouac lived at the house during a crucial point in his career. *Research Center, Orange County Regional History Center.*

Some of DeWitt's images of Kerouac now hang in Orlando's Kerouac House and reside in the collections of the Orange County Regional History. But for a long time they had vanished from view and memory and it took Kealing's pursuit of Kerouac in Florida to find them.

In the late 1990s, Kealing was doing an interview when out of the blue his subject asked him if he was "the guy doing all that research on Kerouac."

"There's a guy who shot Kerouac in Orlando for *Time* magazine," the fellow told Kealing, but he couldn't recall the photographer's name.

Kealing's cyber-sleuthing revealed that Jack Kerouac had indeed been featured in a February 1958 issue of *Time*. He promptly ordered a copy from a seller of old magazines in New York, and when it arrived and he saw the photo and the credit underneath—Fred DeWitt—his heart beat a little faster.

For years Kealing had searched for a visual record of Kerouac in Central Florida with disappointing results. Now, a look at the phone book revealed that Fred DeWitt was only blocks away.

"I hadn't thought of Kerouac in years" when Kealing approached him, DeWitt recalled in a 2004 interview. But a visit with Kealing to 1418½ Clouser Avenue brought vivid details back after more than forty years.

"I remember driving up there with my car, and he helped me unload my stuff," DeWitt recalls. "He was very friendly with me…a nice person and well-spoken." DeWitt remembers being introduced to Kerouac's mother, Gabrielle, with whom the writer shared the apartment, and he remembers that Kerouac had a cat. Some of the pictures he took showed Kerouac petting it. Everything had gone well with the assignment, until his shock weeks later when he saw the issue of the magazine.

"The latrine laureate of Hobohemia," *Time* had wisecracked about America's newest literary sensation, the man who had been reluctantly christened "the king of the Beats." The article struck DeWitt as mean-spirited and cruel. He went back to Clouser Avenue and knocked on the door.

"Man, I want to apologize to you," he told Kerouac, explaining he had nothing to do with the article. Don't worry about it, Kerouac told him; he was getting used to it.

Years later, the article has long been forgotten. But DeWitt's photos, Kealing found, miraculously still existed on contact sheets, which *Time*'s archivists found and e-mailed to him. When he opened the file, "It was like cracking open a time capsule," Kealing writes in his book. Through the work of digital photo expert Joe Brooks, the contact sheets yielded prints of DeWitt's long-lost images of an American icon at an important juncture in his career, in Orlando.

"He rented this place for forty-five bucks a month," Kealing says, looking around the bright apartment on Clouser Avenue that is now an Orlando Historic Landmark. "His entire career was transformed while he was living here. He was a struggling writer who had written a ton of books by the time he lived here, but only one of them had ever been published…and he'd been trying for months to get this crazy scroll book [*On the Road*] published, and publisher after publisher had just laughed at him."

Finally one of them, Viking, took a chance, and by the time Kerouac rolled into Orlando in 1957, all that was about to change.

Kerouac's friend the composer David Amram (himself an American cultural treasure) can remember when the girlfriend Kerouac wrote from Orlando wired him thirty dollars so he could take the bus and come up to New York to visit when the book was published, to see the advance reviews. They stood outside by a newsstand and waited for the *New York Times*, the one that really mattered.

"It wasn't just a book review," Kealing said. "It was a coronation."

Kerouac also "suffered the critical slings and arrows of the literary New York scene's wrath during the 1950s," Amram says, and New York editors weren't so appreciative, either, of the writer's years spent in Florida. Amram remembers one editor loftily remarking, "Florida is where people go to die."

But Florida has always been a haven for artists and writers, Amram says, and the work of Orlando's Kerouac Project reinforces that tradition. Founded by Kealing and by Marty and Jan Cummins, the nonprofit project has achieved not only the purchase and restoration of the Kerouac House but also a successful writers-in-residence program, begun in 2000. And in 2005 the Kerouac Project was able to buy *The Dharma Bums* manuscript that Kealing brought back to Orlando.

Kealing sees it all as a welcome part of a push to boost the arts in Orlando. "We need to add a little cool to the City Beautiful," he says with a smile.

From Highways to
Hall of Fame

When then–Secretary of State (and Orlando's former mayor) Glenda Hood announced inductees to the Florida Artists Hall of Fame for 2004, the honorees included the late sculptor Albin Polasek of Winter Park and a second choice that might puzzle folks new to Florida. "Alfred Hair and the Highwaymen" sounded a bit like a vintage folk or rock group, but Hood was referring to African American artists from the Fort Pierce area who began painting landscapes in the late 1950s. Theirs is one of the great Florida stories, and although they hailed from the southern part of the state, folks in Orlando bought their paintings years ago and have contributed to their recent renaissance.

The old romantic poem "The Highwayman" by Alfred Noyes was one of our family standards when I was child. Ever heard it? It begins,

> *The wind was a torrent of darkness among the gusty trees,*
> *The moon was a ghostly galleon tossed upon cloudy seas,*
> *The road was a ribbon of moonlight, over the purple moor*
> *When the Highwayman came riding—*
> *Riding—riding—*
> *The Highwayman came riding, up to the old inn door.*

Now, Florida's Highwaymen don't have anything to do with the poem, except that images of gusty trees and cloudy seas fit right in with the visions of Florida in Highwaymen paintings: wide hot skies, flowering trees, clouds, palmettos, beaches, marshes out of some dream of paradise lost. It's not a sweet, tidy paradise. Florida is not, after all, a Norman Rockwell or Thomas Kinkade kind of place. As *Highwaymen* author Gary Monroe has said, it's a view "stripped bare of any artifice…gutsy and dramatic."

When it comes to Florida's heritage, "Highwaymen" means a group of black artists from the Fort Pierce area who took to the state's roads to sell their paintings in the late 1950s and 1960s. Some remain active artists.

They "shunned traditional methods and painted quick, brisk images of Florida's tropical beauty in bright colors," Secretary of State Glenda Hood said in an

announcement of their induction into the Florida Artists Hall of Fame. "They sold their creations from the trunks of their cars along Florida's east coast for as little as $20 each, showering the state with approximately 200,000 paintings."

The name is quite recent, says Jim Fitch of the Museum of Florida Art and Culture in Avon Park, who is credited with coining it about 1994. Not all of the artists who have been grouped under the Highwaymen label are crazy about it, but the moniker seems to have captured folks' imaginations for sure. Since about 1995, people have been snapping up these paintings, not just as an investment but because they like them.

Geoff Cook, who long owned a large nursery in Apopka until 2005 when he decided to pursue his Highwaymen obsession full-time, saw his first painting on the cover of a 1998 *Florida* magazine. It was a sunset rich in coral, orange and intense pink.

Maybe it reminded him of the sunset views from a trailer his grandfather owned on Lake Apopka, where he spent time as a boy. "I've got to find one or two of those paintings," he told himself. But as Monroe remarked in a 2001 article about the painters, Highwaymen collectors typically don't stop at one or two. "In Florida today, there is a near feeding frenzy over acquiring Highwaymen paintings, and, like the potato-chip commercial suggests, it seems that nobody can have just one," Monroe wrote.

Florida Highwaymen artists such as the late Alfred Hair sold their paintings across the state from the trunks of their cars for twenty to thirty dollars each in the 1950s and '60s. In recent years, the painters have been honored with membership in the Florida Artists Hall of Fame and have gained favor with collectors. *Florida Photographic Collection, State Archives.*

Cook's website (floridahighwaymen.com) lists the twenty-six painters who were inducted into the Artists Hall of Fame. Among them are James Gibson and Mary Ann Carroll, both active painters during the more than four decades since they began selling paintings.

Gibson's first successes as an artist go back to elementary school days in Fort Pierce, when his skills at replicating popular cowboy images from comic books earned him ice cream money; other kids would buy his drawings for a dime, he said during a 2002 Orlando interview.

It was when he returned to Fort Pierce after college studies at Tennessee State that Gibson got oil paint in his blood. Inspired by Fort Pierce artist A.E. "Bean" Backus, a white landscape painter, and by a former schoolmate, Alfred Hair, Gibson got busy painting.

He remembers Backus helping him get just the shade of blue he was after when he first struggled to mix his paints, and he remembers Hair's competitive spirit to see who could turn out more paintings and get them to customers faster.

Especially, he remembers that first sale, to a dentist, a Dr. Sims, who said, "James, that is really good," and bought the painting for twenty dollars, which was worth a bunch more back about 1960 than it is now.

These days, though, the price tags on Gibson's paintings reach into the hundreds and even thousands, and the folks who are telling him they like his work include Florida Governor Jeb Bush. During all that hoo-ha about vote counting in the fall of 2000—when TV news images kept showing Supreme Court spokesmen at a microphone outside the court's building—Gibson's paintings were on display on the walls inside.

The path of a painter hasn't always been easy, of course, says Mary Ann Carroll, the sole woman Highwayman. But her art gave her a way to make money from home while she was rearing seven children. Carroll had other work, too. She painted houses, did yard work—tough jobs. "Raising seven children, it wasn't easy, but I didn't look at it as being hard," Carroll said. "You do what you have to do."

For Carroll, too, painting was not just an economic blessing but a pleasure— "from my youth, I could draw anything I could see," she recalls. Asked if he too painted in part because it was fun, Gibson says sure. But after all these years, the recent success he and Carroll and the other surviving Highwaymen are enjoying has got to be sweet.

"I'm having big fun now," he says.

THE LADY WHO SWAM WITH
THE CREATURE

"New thrill Wonder 3-D horrorscope," proclaimed ads for the 1954 horror classic, The
Creature from the Black Lagoon. *"Not since the beginning of time has the world beheld
terror like this!…Centuries of passion pent-up in his savage heart!" If memory serves me
right, Howard Junior High School had a print of this Florida-filmed saga about 1956 and
used it to keep kids occupied during crowded lunch hours by showing installments of it in the
big auditorium. Either then or later, I've seen it over and over, never guessing that one day I
would chat with the women who escaped those webby clutches.*

I just talked with a woman who was captured by the Creature—you know, the
one from the Black Lagoon. She was dragged to his lair deep below the water's
surface. No goggles. No scuba tanks. And no computer-generated effects—just real
underwater swimming, Florida-style.

Ginger Stanley Hallowell not only survived but thrived, living happily among us
for years in Orlando, right in the Dover Shores neighborhood.

Many great movies have been filmed in our state through the years—and, no,
I wasn't thinking of *Ernest Saves Christmas*, although that was indeed filmed in
Orlando. Florida-filmed movies include *The Yearling*, *The Rose Tattoo*, *Ulee's Gold*,
Edward Scissorhands. But for a great Florida flick, you can't beat the one in which
Hallowell grappled with the Gill-Man.

Some say Wakulla Springs, where much of the original *Creature from the Black
Lagoon* was shot, is the deepest, most powerful spring in North America. That's
where Hallowell said Ricou Browning, who swam into horror-movie Valhalla as the
Creature, learned how to swim underwater by taking gulps of air from a hose in a
method developed by Newt Perry, the father of underwater shows in Florida.

Hallowell, too, learned from Perry, who about 1949 recruited the recent Sebring
High School grad from a beauty contest in Ocala to be a "mermaid" at Weeki
Wachee Springs. "I first swam there, which is where I learned my underwater
skills," Hallowell said in 2005.

Weeki Wachee is also where she met Browning, another young swimmer, born in
Jensen Beach. They both honed their skills where the mermaids swim and moved
on to jobs at Silver Springs when Hollywood came calling about 1953. The *Creature*

from the Black Lagoon producers wanted a Florida location that would look like the Amazon jungle, where the Gill-Man lurked in his underwater lair.

The Creature would become the last of the great Universal Studios monsters, a lineage of horror-movie royalty that included Bela Lugosi's Dracula and Boris Karloff's Frankenstein monster. Color? Who needed color? These ghouls thrilled beautifully in black and white.

As the underwater Creature, Browning, then just twenty-one and a student at Florida State University, created the distinctive torso-twisting swimming style that has been a hallmark of aquatic horror films ever since. So declares screenwriter and film historian James Ponti in his book about Florida and the movies, *Hollywood East*.

Browning and Hallowell, who did the swimming for leading lady Julie Adams, made the underwater scenes look easy. Browning's "style of swimming was sort of like an underwater crawl," Hallowell recalls. The Hollywood folks had been used to seeing people swim underwater "like a big breast stroke, then kick-kick-kick," she said, and hadn't seen anything like Browning. Or like Hallowell's ability to hold her breath and maneuver underwater for at least two minutes between gulps of air.

The young Florida swimmers created two of the original *Creature* feature's most memorable moments. One is a creepy underwater ballet in which Hallowell swims near the surface of the water, and the Creature swims below her, copying her movements and reaching up for her foot. More than one observer has wondered if this scene influenced Steven Spielberg in *Jaws*.

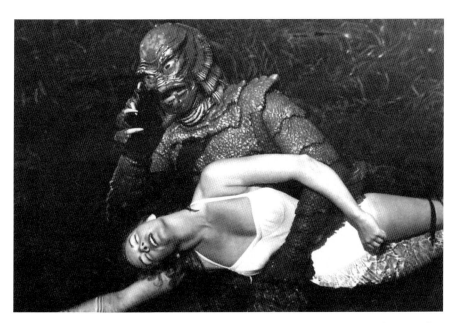

Ricou Browning, as the Creature, has Ginger Stanley Hallowell in his clutches in *Revenge of the Creature*, a sequel to *The Creature from the Black Lagoon*. Hallowell has made her home in Orlando for many years. *Florida Photographic Collection, State Archives.*

Another memorable scene—the fast, deep dive to the Creature's underwater lair—happens quickly in the movie, but it's the one Hallowell says fans often ask her about at such events as the Tallahassee Film Society's Creaturefest at Wakulla Springs.

In 2005, Dan Western, one of the society's founders, recalled the society's big fiftieth anniversary bash for the movie in 2003. Then, people came from all over the United States—California, Arizona, Virginia. One man, a NASA employee, drove all the way from Texas. After more than a half-century, the Creature is still in the swim.

"Hello, Gorgeous"

Workers were busy scrubbing and polishing the wrestling ring at Orlando's American Legion Arena, promoter Milo Steinborn told reporters on an autumn day in the early 1950s. Only the best would do for that night's star attraction at the arena, one of the most famous men in America and, in retrospect, a true show business pioneer.

Ladies and gentleman, here comes the peroxide prince, the curly-haired Hercules, the glamorous grunter, the marcelled mangler, the razzle-dazzle wrestler—Gorgeous George!

Sure, it's hard to imagine now, but in 1953, bleached curly locks on a guy were a real shocker and Gorgeous knew how to make the most of them. Lots of presidents had long hair, he told an interviewer, the *Orlando Sentinel*'s Jean Yothers. Four had been wrestlers, he said, ticking off the names of Presidents Buchanan, Lincoln, Teddy Roosevelt and the Numero Uno, George Washington—whose profile Gorgeous rather resembled.

Born George Wagner in Nebraska in 1915, he had begun professional wrestling in his teens and continued for a decade with little success. He wasn't big—5 feet 9 and 215 pounds—and he was a just-average wrestler, according to a Professional Wrestling Hall of Fame biography.

He thought about giving up, but instead he invented tactics that changed not only his fortunes but the sport itself and other facets of entertainment as well.

"Muhammed Ali, Little Richard, Liberace, and numerous other figures in both sports and entertainment" owed something to Gorgeous George, the biography says. "One is hard-pressed to think of a more influential public figure, let alone a professional wrestler."

He called himself "the Human Orchid," and eventually drove a Cadillac in a hue to match. His ring entrances were legendary and took almost as long as his matches. He was the originator of entrance music ("Pomp and Circumstance") and threw gold-plated bobby pins called "Georgie pins" to the ladies in the audience. In Orlando in 1953, he told reporters he had tossed way more than two million of them.

Fans loved his theatrics, both before and during the matches. They flocked to see him in record numbers, both in live matches and in the new medium of

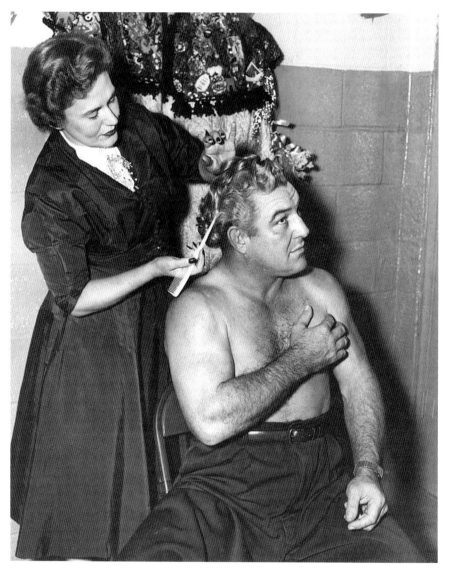

Wrestler Gorgeous George (George Wagner) gets his famous locks styled before a 1953 appearance at Orlando's American Legion Arena, promoted by Milo Steinborn. *Orlando Sentinel* files.

television. Watching on her first TV set in the Pennsylvania steel country, my grandmother Florence Durbin Dickinson adored him, and when she rode the train south for winter visits, my dad took her to the American Legion Arena near Lake Ivanhoe to see the wrestling matches; I think she might have even seen the peroxide prince there.

A young Bob Dylan saw him up in Hibbing, Minnesota, about that time, Dylan writes in his memoir *Chronicles: Volume One*. Dylan was a struggling teenage musician, finding little encouragement. But sometimes all it takes is a wink or a nod to get going again. "That happened to me when Gorgeous George the great wrestler came to my hometown," Dylan writes.

There he was, a high school boy performing without anyone paying much attention to him in the lobby of the National Guard Armory. Suddenly the doors burst open and there was Gorgeous himself, roaring in like a storm "in all his magnificent glory with all the lightning and vitality you'd expect," Dylan writes. "He had valets and was surrounded by women carrying roses, wore a majestic fur-lined gold cape, and his long blond curls were flowing."

The wrestler didn't break stride but looked straight at Dylan, his eyes flashing. And he sent the boy a wink that seemed to say the young singer was doing all right. Dylan says it was "all the recognition and encouragement" he would need for years to come.

That story put my grandmother's 1950s fondness for Gorgeous in a whole new light. I used to think she was being a naïve old lady to fall for the fake glitter of a corny charade. Now I think she was a lot smarter than that. Like the boy who would become Bob Dylan—like Gorgeous, another self-created American wonder—she saw beyond the peroxide curls. She saw all the verve and fun of a man who didn't follow the prescribed path but carved a new one of his own and was having the time of his life.

ALL IN THE FAMILY

I can't remember the first time Stewart Kerr telephoned me, but I'm sure it was about something he wanted to correct—if a caption for an old photo said something was on the east side of Orange Avenue instead of the west, Stewart would know. And call. "Hello, dear," he would chortle into the phone, with great har-har-hardy-harring relish. Through the years, I began to create a persona for him a little like Phil Harris, the radio bandleader and comic on the old Jack Benny shows. Stewart had a gravelly voice and a slightly rakish air that fit with memories of Harris songs such as "Smoke Smoke Smoke (That Cigarette)." But he probably was nothing like Phil Harris. Now I'll never know. I began to worry a bit when the calls stopped; but hurricanes and other disasters have a way of sucking up attention and energy. It was only just before New Year's of 2006 that I learned that Stewart had died during the summer.

I had thought he was my own private benign heckler. Because Stewart Kerr loved to recall Orlando in the 1940s, I assumed that and I and my history column were his first loves at the *Orlando Sentinel*. But, boy, was that wrong. He had beloved phone companions outside the *Sentinel*, and, judging from the newspaper's archives, at the paper. Stewart regularly contacted a diverse group ranging from public editor Manning Pynn to columnists Greg Dawson, Jerry Greene and Commander Coconut—and especially features writer Linda Shrieves, whom he called every day.

He called her the first time after she wrote a story about an Orlando High School reunion, Linda recalls. He called again in 1994 when she wrote "about a man who bought yearbooks that contained pictures of famous people."

The famous face in Stewart's 1948 OHS yearbook, when Stewart was a junior, was the future "astronaut's astronaut," John Young, and although Stewart no doubt enjoyed calling Linda about what this prize might be worth, he probably never had any intention of selling his treasure.

A retired engineer—Linda and I think he worked at Cape Canaveral before his retirement—Stewart admired Young immensely.

Soon after Young retired from his amazing NASA career at the close of 2004, Stewart wrote a letter to the editor promoting a statue of the astronaut near Princeton Elementary, Young's grade school.

A photo captures a slice of Orlando High School life in the 1940s when William R. Boone reigned as principal on the Robinson Street campus, now Howard Middle. Stewart Kerr was in the OHS class of '49. *Research Center, Orange County Regional History Center.*

Stewart apparently lived not far from that spot, on Gunnison Street. Judging from the 1987 obituary for his father, Stewart V. Kerr Sr., young Stewart must have gone to elementary school in Chicago. The family moved to Orlando in 1945.

I remember him telling me he went to junior high school at Memorial, the old brick school long gone from the west shore of Lake Eola, where a hotel-turned-condo now stands.

His mother had worked downtown somewhere—perhaps in one of the five-and-tens—and he would walk for haircuts after school to a barbershop in the Angebilt Hotel before checking in with her.

During high school in the postwar '40s, he had various after-school jobs, including working as an assistant for various photographers. He remembered being sent on errands to the Division Avenue studio of E.B. Mitchell, then the leading photographer in Orlando's black community, where he observed not only Mitchell's professional generosity but also a lack of racist attitudes in the dealings between him and white photographers. Stewart remembered finding that "strange and refreshing" in the segregated South.

After high school, he served in the military, Linda recalls him telling her. He went to the University of Florida on the G.I. Bill. He was, as Commander Coconut noted in a farewell to him, "wonderfully opinionated and very smart." His opinions,

expressed in phone calls, are sprinkled all over the *Sentinel*'s archives on topics from penalties for pornography to politics.

When a "Soundoff" question asked, "Did Al Gore's acceptance speech hit the home run he needed?" Stewart quipped, "No way. The man struck out on three straight pitches. The worst part about it is that he never took the bat off his shoulder."

That was in 2000, a few months after Bernice Kerr, the mom Stewart used to meet after school more than a half-century earlier, died at ninety-one. She too lived at the Gunnison Street house that was his last residence. He was her only named survivor and after her death, he was pretty much alone.

Unlike his hero Young, Stewart was far from famous. There will be no road named for him, no brass plaques. No one would be more surprised than he to find himself discussed in a book about the history of Orlando.

Stewart's many calls, you see, were never aimed to draw attention to himself or to get publicity. He just had to share information; he seems to have imbibed every inch of the newspaper every day and wanted to get in his two cents, by golly. And so, in an odd way, the unseen voices to whom he talked weekly or daily or whenever the spirit moved him became a kind of family. "Have a good one!" he'd say when he hung up.

You too, Stewart. Truly, thanks for your memories. Your big, sometimes crabby, too-busy-to-talk-now, ink-stained, unseen family misses you. We're glad that you read, you cared and you called.

MIRACLE ON ORANGE AVENUE

A friend who grew up near San Francisco in the 1950s used to joke that her childhood idea of a safe haven wasn't a bomb shelter or even a church but the grand old department stores around that city's Union Square. Orlando's department stores of that era weren't on the same scale, but they were the same genre. On Orange Avenue at Central Boulevard, Ivey's on the east and Dickson & Ives on the west sat at the city's center, comfortable rivals who shook hands at Christmas through the big illuminated star that hung between them for the holidays. In recent years, "Friends of the Star" gather downtown on a Sunday morning in late November to cheer on workers from OUC, the city's utility, as they painstakingly return the star to its annual place in Orlando's firmament.

"Two of Orlando's largest department stores may brood across the avenue at each other all year long. But their combined light shines out at Christmas," the Orlando Sentinel said about the city's holiday star in 1956. It had debuted the year before and cost a whopping $2,500.

The decoration was the brainchild of Dickson & Ives's Wilson Reed, his daughter Peggy Reed Mann of Orlando says as she looks up at the building that supports the star on the west and once housed Dickson & Ives. Her late father started out as a stock boy there in the 1920s and had worked his way up, eventually buying the classy emporium. He was at Dickson & Ives for thirty-five years until he sold it in the late '50s, Mann says. "There was a fire escape up there" on the building when she was a child in the 1950s, she recalls, "and we used to come out on the fire escape and watch the parade, if we weren't riding in the parade."

Those were the days of the original star. The one in use recently dates from 1984, when Mayor Bill Frederick revived the tradition. The first incarnation looked a lot bigger, Mann says. "You could stand blocks up the street, and it was like it was in your lap—it was just enormous." The impression was created in part by the many strings of lights from which the central star was suspended.

The downtown decoration's heritage is interwoven with the retail past of downtown and with memories of the Orlando Christmas parade that Mann mentioned—for decades a fixture of Central Florida's holiday time.

The 1950s Orlando Christmas star hangs above Orange Avenue, downtown's main street. Ivey's department store is at left, behind the woman in the foreground, and Dickson & Ives is at right. Strings of colored lights surrounded the star. Orlando Sentinel *files*.

"It was a great Christmas parade because everybody came in from everywhere to see it," Bill Bean of Orlando says as he watches the big star being swung into place. Bean's family would always drive into downtown Orlando from Winter Garden, where they lived at the time, he says. Tops among his boyhood memories of the parade were Orange County's longtime "Sheriff Dave Starr and his horse, and his lovely wife and her horse. A few years ago I could even have told you the horses' names, too," Bean says.

Like Mann and other members of the Reed family, Bean is among an ad hoc group of star-boosters who have gathered at the old heart of Orlando's downtown to support the utility workers who hang the star with orange juice, coffee and bagels and to swap reminiscences.

"This is Christmas Day for me," says the group's organizer, Jack Kazanzas, as he circulates among the onlookers, snapping photos and making introductions. A longtime Central Floridian who graduated from Orlando High in 1948, Kazanzas in 1998 organized a movement to raise several thousand dollars to refurbish the star after the city had targeted it for retirement.

"He cares, and I like that. I like it when somebody cares about something and then takes action to support it," Kazanzas's friend Banning Radler says as she invites the stargazers to have some good coffee.

Kazanzas's efforts to save the downtown holiday icon have paid off. In November 2005, the star reappeared in its traditional spot in a transformed guise. Designed by Cindy White and constructed by Cinnabar Florida, both of Orlando, the new incarnation encases the star in an aluminum frame that expands it from ten to nineteen feet wide and uses about two thousand light points.

Looking up at the star, I'm transported back to those old department stores that it originally united in holiday spirit. In Ivey's, a patient saleswoman taught me to knit on Saturday mornings on one of its upper floors. Tucked high in a closet somewhere, I still have the sweater I made in fashionable 1950s aqua, with a sailor collar. After I worked on it, I probably went downstairs to buy the newest Nancy Drew adventure in the first-floor book department, near the "notions," an odd assortment of useful stuff.

A whooshing, mysterious system of pneumatic tubes carried money and charge slips up and down throughout the building. When you shopped for clothes, you weren't handed a plastic tag showing the limit you could carry into the fitting room. At the elevators, an elderly man in a uniform nodded greetings and commanded the controls with white-gloved hands. Shopping was fun. It's no wonder my favorite nostalgic holiday movie is *Miracle on 34th Street*, in which the real Santa Claus works in a department store. Santa's no dummy. In those long-ago holiday seasons, those stores seemed a pretty good place to be.

THE BRIGHT LIGHTS OF COLONIAL PLAZA

The down-to-the-wire shopping days right before Christmas always tug my thoughts to the late 1950s and my dad. In his Depression-era youth, the retail season didn't stretch its tentacles back into October, and during his boyhood, I'll bet the tree didn't go up until Christmas Eve. On either that night itself or one soon before it, he would come home from a long day at his grocery store, retrieve the little stash he had literally "socked" away for just this night and say surreptitiously, "Let's go get something for your mother."

I learned early in life that if I didn't want the outcome of last-minute Christmas shopping trips with my dad to be some well-intended but ill-starred appliance for my mother—some gizmo for curling hair or making waffles—I should arm myself with a list of ideas. So off we would go, in the well-worn truck he used at his grocery store. If the night was clear and cold, the smell of the truck's cracked leather seats mingled with the wood smoke from fireplaces in homes around Lake Lawsona.

We would inevitably end up at Belk's department store at Colonial Plaza, Orlando's first shopping center, still sparkling from its opening in 1956. That day, a cartoon on the *Orlando Sentinel*'s front page had declared it the "biggest and classiest thing to ever hit Central Florida."

What is now called Colonial Plaza on East Colonial Drive sits on the same land but consists of almost all different structures, built in the late 1990s after Colonial Plaza Mall was torn down. By its demise, the original shopping center had become an enclosed mall and had grown much larger than the original twenty-five stores.

A few days before its first grand opening, newspaper stories offered an effusive "sneak preview of the Southland's finest shopping center." Opening day would feature "free candy for everybody" and prizes that included six twenty-one-inch TV sets—hubba-hubba—a 1956 Plymouth and two all-expense-paid trips to Havana! Perhaps the biggest attraction was the two thousand free parking spaces. Downtown Orlando's retail core boomed in the 1950s, but shoppers often circled blocks and lots to find a metered space. Central Florida still grapples with the attachment to free parking that Colonial Plaza and its successors engendered.

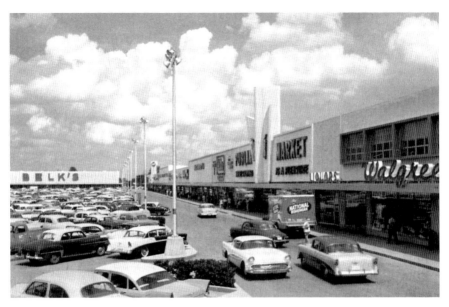

A postcard shows the original Colonial Plaza, Orlando's first shopping center, in the late 1950s. The Barnes & Noble store now on East Colonial Drive sits about where the Publix was. *Collection of Joy Wallace Dickinson.*

On the inaugural day, every spot was full, as visitors packed the center for the brief ribbon-cutting ceremony featuring Orlando Mayor J. Rolfe Davis and Orange County's longtime sheriff, Dave Starr, a fixture at parades and public events. In less than a year, the *Sentinel* declared, what had been a T.G. Lee Dairy pasture had been "turned into an ultramodern glass, chromium and gaily hued amalgam of buildings."

At the center's west end was a Walgreens, one of the few stores in Orlando that was open on Christmas itself. This was the place harried parents rushed after present-opening to find batteries for that toy from Uncle Fred up North, which had arrived without them—and other Christmas morning crisis shopping.

At the other end of the row of stores was the legendary Ronnie's Restaurant and Pastry Shop. One of the early notable episodes in Ronnie's history concerned neither its famous penchant for rules nor its ice cream extravaganzas. "Nude Man Shops Colonial Plaza in Comfort—Until Cop Comes" reads a 1959 headline. Apparently, a thirty-three-year-old man calmly walked into Ronnie's in the buff, sat down, went to the water fountain and then exited.

Perhaps he had been headed to Belk's, which sat in its own building, perpendicular to the Ronnie's end of Colonial Plaza. Besides having the first department store escalator in Orlando, Belk's offered attractions for the young teen crowd, including Bill Baer's "Melody Corner"—"Columbia record-phono headquarters," Baer's ads said. For attire to wear while dancing to the music sold there, teenage girls

might find net crinolines—"triple layers for extra bouffancy," in aqua, black, green, salmon, gold, white, beige and pink, a 1956 Belk's ad reads.

With this big-skirt finery, one might dream of twirling one's way onto the stage at TV's *American Bandstand*, presided over by a young Dick Clark. But then, a preteen girl didn't need store-bought "bouffancy"—what a funny word—to feel light and happy on a cold, starlit Central Florida night, rumbling down brick streets in an old Ford truck with her dad, headed for the bright lights and, until 9:00 p.m., holiday shopping at Colonial Plaza.

Lessons in Dance and in Life

In the Orlando of memory, many girls' upbringing included a class in ballet at schools run by the Royal and Ebsen families. And although only a few boys joined in the pas de deux, by the time their early teenage years arrived, many boys' mothers made sure they were signed up to take "Pounds," along with the young ladies.

"To me she was the mother of dance in Florida," Kip Watson, then director of the Osceola Center for the Arts, said in 1996 on the death of Edith Royal. Watson, a co-founder of the professional Orlando Ballet company (formerly the Southern Ballet Theatre), said that without Royal, "none of us would have done what we did. We never would have had a Southern Ballet Theatre."

"She gave me a cherished gift—my love of dance," said Watson's sister, Barbara Riggins, also a co-founder of Orlando Ballet and its former artistic director. A sixteen-year-old Riggins was in the cast when Royal's fledgling student company gave its first performance in 1953 with the Florida Symphony Orchestra, performing three ballets including Stravinsky's *Petrouchka*.

But "first on the program is the Nutcracker Suite," the most popular of all ballets, the *Orlando Sentinel* reported. Edith Royal, veteran of concert stage and television, would dance "the delicate chiming music of the Sugar Plum Fairy, queen of the candy inhabitants of Tchaikovsky's wonderland."

The Orlando City Ballet, a nonprofit, student-based company, also traces its heritage to Edith Royal and her husband, Bill, who died in 1990. Armed with copies of decades-old clippings about Royal, Orlandoan Marc Gibault of the company's guild hopes to secure a visible place for Edith Royal in arts history in the Florida Artists Hall of Fame. "She was the one who really brought ballet to the area," Gibault says.

Royal arrived in Orlando in 1943 from her hometown of Philadelphia with her husband. She had met Bill Royal at church about 1934, when she was sixteen, and they were married six years later. Trained as a professional dancer, Edith Royal had performed and taught dance in Philadelphia.

Bill Royal's managerial job with Royal Crown Cola brought them to Orlando, one biography in Gibault's archives says. Another interview with the Royals, likely

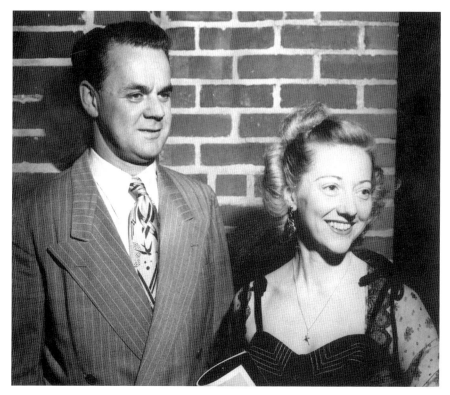

Edith and Bill Royal were photographed in 1957 at Orlando's Municpal Auditorium. At one time their dance school was in Winter Park; another longtime location was in College Park on Smith Street. *Research Center, Orange County Regional History Center.*

from the 1960s, says he worked for Crown Can, a job he decided to leave after the couple started their dance studio. "'From Cans to Can Can,' as he puts it," the clipping says.

But before Edith Royal started her first dance school in Orlando in 1949, she taught at the school of the dean of Central Florida dance, C.L. Ebsen. Ebsen had begun teaching in Orlando in 1921, and had started the Ebsen Studio of the Dance at Pine and Hyer Streets in 1922. Its graduates included his children, Vilma, Helga and Buddy.

Students of film history (as well as Central Florida history) will recall that before he was Barnaby Jones, Jed Clampett, Davy Crockett's sidekick or Audrey Hepburn's discarded husband in *Breakfast at Tiffany's*, Buddy Ebsen was a super dancer. He was the original Tin Man in *The Wizard of Oz*, a role he was unable to play because he was allergic to the makeup.

By the time Edith Royal arrived in Orlando, Maestro Ebsen, Buddy's father, was no longer teaching and Royal taught at his studio for about five years. With other dancers and supporters of dance, Royal and C.L. Ebsen founded the Central

The spring dance was a highlight of the Pounds's dance lesson experience over the years in Orlando. In a span of seventy years, Ruth Pounds and Peggy Jo van den Berg, Pounds's daughter, taught thousands of Orlando teens and preteens. *Research Center, Orange County Regional History Center.*

Florida Ballet Company about 1945. The company fulfilled a longtime dream of Ebsen's, a 1949 story said. "I dared not come out in the open with the idea for a ballet company here for many years, because it seemed hopeless," Ebsen said. "Now the idea had taken root throughout Florida, and we have ballet groups in several cities."

That the idea has really taken root more than a half-century later has much to do with the legacy of Edith Royal, who went on to train three generations of dance teachers and dancers who have enriched the arts in Central Florida and the nation.

So if you see *The Nutcracker* during the holidays, in any of a number of fine presentations by Central Florida companies, remember the lady who danced across the stage at Orlando Municipal Auditorium in 1953 as the Sugar Plum Fairy, queen of a holiday wonderland.

Two more queens of Central Florida dance, Ruth Pounds and her daughter, Peggy Jo van den Berg, taught generations of Orlandoans not only the waltz, the fox trot and other smart moves on the dance floor, but also how to comport themselves as polite human beings—how to greet people courteously, how to ask someone to dance, how and when to write thank-you notes.

And how not to talk to with gum in your mouth. Please.

Ruth Pounds, who started it all in 1935, was so well known that her name became synonymous with what she taught, a *Sentinel* article noted in 1987: "Children didn't take dance; they took Pounds." That could lead to confusion for some newcomers, Ruth Pounds recalled. "We'd have mothers who would come and say, 'My neighbors told me I must get my children into Pounds. What is Pounds?'"

What became "Pounds," long housed at a studio on Edgewater Drive in College Park where pupils lined up for lessons on the maple dance floor, first began in Ruth Pounds's living room on Clifford Drive in Orlando.

Voted best dancer during her Orlando high school days, Pounds got a call about 1934 from teenager Jane Maguire, who remembered Pounds's gift for dancing. Would she be willing to teach her? Maguire asked. Pounds said yes, and the next time Maguire came for a lesson, she brought two more pupils. They each paid twenty-five cents and put their money on a vase on the mantel.

For seventeen years Pounds taught students in the living room of her Spring Lake Terrace home, with as many as seven classes on Saturdays. In 1953 she and her husband, the late Roger Pounds, built the College Park studio, and van den Berg joined her mother as a teacher.

Their thousands of students over the years went on to become teachers, doctors, judges, homemakers—every conceivable role in life, including the Phantom of the Opera. Davis Gaines, one of the longest-running Broadway Phantoms, was a Pounds student and teaching assistant as a teenager.

Van den Berg continued lessons after the family closed that studio in the late 1980s and wrapped up seventy years of an Orlando tradition in the spring of 2005. The following fall, members of the Historical Society of Central Florida honored the Pounds tradition with a fête and fundraiser to support the preservation of Orlando's history.

March to the Future

The retired band directors have been friends for at least forty years, since the days when James Wilson wore a bow tie and Del Kieffner sported a flattop—and since an era in the South when white and black men didn't routinely meet for lunch as these two still do. More than forty years ago, they shared one of their richest experiences, during a community effort they remember as a new high point in Orlando's race relations.

In July 1964, James Wilson's Jones High band boarded a train north for an eight-day trip, after a fund drive that also sent Del Kieffner's Edgewater Eagles on the same venture in May. "It was a coming-out session for the community; that's the way I looked at it," says Wilson of Orlando, whom generations of former Jones students still call "Chief." It was a marching step forward, out of segregation and into possibility.

As a boy in the small Indiana town of Jasper, Kieffner had known nothing of segregation and first encountered it after college while playing in a Marine band in the early 1950s. During a concert date in Raleigh, North Carolina, band members had piled into a restaurant and were shocked when they were told the pianist, a black man, would have to eat in the kitchen. "We all turned around and left," Kieffner of Winter Park recalls.

When he moved to Central Florida in 1957 and saw signs indicating "colored" and "white" at water fountains and restrooms, "I couldn't believe that," he recalled. "I thought, 'What are they talking about?'"

Wilson knew about segregation all too well, as a boy growing up in the black section of Sanford, where his father earned nineteen cents an hour working for the railroad in the 1940s. He has his racial horror stories but he prefers not to dwell on them. People can always find ways to create hatred, he says; he would rather work for change and get things done.

That's what he did at Jones a half-century ago, when he began to build a band from scratch in 1950. He was fresh out of Florida A&M University.

"When he came, he looked like a little boy," Erlene Spinks says, laughing. Now in her eighties, she was one of the band parents who offered Wilson vital support. "I thought, 'What is this kid going to do with these other kids?'"

Led by James "Chief" Wilson (left), members of the Jones High Band and chaperones pause for a picture in front of the nation's Capitol on their train trip from Orlando to the New York World's Fair in the summer of 1964. *Courtesy of James Wilson.*

The young man soon dispelled any doubts, working long days including weekends, offering lessons to younger children. "He was just like another parent," Spinks says. "He handled them so well; he respected them."

In its first years, Wilson's band members wore hand-me-down uniforms from the old Orlando High School. Mothers sewed a green stripe by hand on the trousers to convert the orange and white of Orlando to the orange and green of Jones. Soon, Wilson had shaped the Jones band into a marching legend in Central Florida, earning top marks at state competitions and sending a thrill through crowds at Orlando's annual Christmas parade with the fast-stepping techniques Wilson had learned at A&M.

"Of course, music was the first thing to break down the barrier of discrimination" in the United States generally, he says. By early 1964, when the civil rights movement was in full swing, Wilson's Jones band had become an object of pride for both black and white Orlandoans.

"We've been asked to participate in the World's Fair," he told an *Orlando Sentinel* writer early that year, "but we're not certain we can attend because of the money involved."

The New York World's Fair was big stuff in 1964. It drew an estimated fifty-one million people to Flushing Meadows Park in two six-month summer seasons, opening in April 1964 and closing in October 1965.

Florida had invested in a high-profile pavilion at the event, featuring water-ski shows from Cypress Gardens. School bands from throughout the state were invited to play at the pavilion and launched fund drives for their trips, which for most schools included a stop in Washington.

Early in the spring, mention of the Jones band's fund drive appeared mostly in pages of the "Negro Edition" of the *Sentinel*, one of the paper's community editions that appeared on pink or green pages. One clipping noted a total of $443.22 raised through carwashes and gifts, scarcely enough to get the band out of Florida.

That soon changed. The newspaper had announced a drive to send the Edgewater band to the fair. Spinks, the Jones parent who had known Wilson since he arrived at Jones, now worked at the paper, cooking meals for the pressmen and, when the occasion arose, for its powerful owner, Martin Andersen. "Mr. Andersen used to talk with me," Spinks recalls. He would ask about her children in college and other matters.

"She got a chance to talk to him," Wilson remembers. "That was our inroad."

Soon, an announcement appeared in the main paper. "Send both bands to fair," the headline read. The newspaper would be accepting contributions to send Edgewater and Jones students on what for many was the trip of a lifetime. The drive began to gather steam, as residents and businesses pitched in with imaginative fervor. Shamrock Oil donated four cents a gallon from its sales at twelve stations during a three-day period. Minute Maid brought the Goodyear blimp to town and offered rides to boost the band drive. The *Sentinel* created a downtown traffic jam with a sale of tabebuia trees for $1.50 each. Cars "were lined up all along Orange Avenue," Kieffner recalls. After forty years, the trees' bright yellow flowers still make Wilson smile each spring. "Every time one blooms, it's a joy," he says.

As the two bands worked to raise money, doors opened to understanding and change. "A lot of the kids were a little reluctant about one-on-one" interaction, Wilson says, but through their joint efforts, "they became acquainted with each other, and it brought about social relationships that didn't exist at the time."

For the students on the trip, doors to possibilities opened wide as well, says Carl MaultsBy, a nationally respected musician and composer who was captain of the Jones band in 1964. Now the director of music ministries for St. Mark's Episcopal Church in New York, MaultsBy also teaches at Florida A&M and has been splitting his time among New York, Tallahassee and Orlando.

The trip "confirmed what I knew intuitively," MaultsBy says—"that there was a world beyond the then-segregated South that was very different," and he wanted to be a part of it.

He remembers a visit to New York's Lincoln Center as awe-inspiring. "I knew that one day I wanted to be on that stage," he said, a dream that indeed has come true more than once.

Even more inspiring for MaultsBy was the band's stop in Washington, D.C.

"You have to think of the times," he said. The Reverend Martin Luther King Jr. had given his "I Have a Dream" speech at the Lincoln Memorial just the year before. When the young band captain saw the place where King had spoken, he was able to see, too, that the world of King's dream was "a foreseeable reality in my lifetime," MaultsBy says.

"That trip was what made me see that…the future was at hand."

When Disney Was a Mystery

Rumors were thicker than the sticky July air in Orlando in 1965. A mystery buyer represented by Miami attorney Paul Helliwell had acquired about thirty thousand acres in Orange and Osceola Counties for a price of "more than $5 million in cash," a July 9 Sentinel *article reported. A meeting between representatives of the buyer and Osceola officials had been set for the following November. What could it mean?*

The "mystery industry" was Central Florida's biggest-ever secret—"all anyone in town was talking about" that summer, *Sentinel* columnist Charlie Wadsworth would say years later. Although it was newswoman Emily Bavar who would break the story in October 1965, at the time Wadsworth and his "Hush Puppies" column had gained the obsession as an extra beat for almost a year, he told an interviewer in 1988.

"It seems almost every day there was a new lead of some kind to follow…at cake sales, symphony openings, cocktail parties, everywhere," Wadsworth recalled.

The speculation produced corny jokes—"Hey, have you heard? The mystery industry is Ford, and they need all that land to grow hay for their Mustangs"—along with rumors that the secret buyer would be revealed as Howard Hughes or Boeing aircraft or the Rockefeller family.

Even the first legal secretary hired for the company didn't know who her employer was, Julia Switlick said in 1988. After a rather odd job interview with a Miami law firm that summer of '65, she was told work wouldn't begin until January, and it was a long, worrisome wait and so hush-hush.

"I was worried I might be working for the communists," Switlick said in 1988. "In those days, just saying someone was a communist was the worst thing you could do."

Switlick need not have worried about communists, although the security measures used by Walt Disney's team to pave the way for Walt Disney World may have surpassed those of clandestine cells, as Rollins professor Rick Foglesong writes in *Married to the Mouse*. Methods included a special phone relay system. "If we wanted to talk to anybody at Disney, we could not call Disney. Instead we had to call a special number in New York," a partner of Helliwell's told Foglesong. "The other rule was that nobody at Disney could talk to anybody in Orlando, period."

Walt Disney (left) talks with Florida Governor Haydon Burns and Martin Andersen, publisher of the *Orlando Sentinel*, in 1965 during a press reception at the Egyptian Room of the Cherry Plaza Hotel. *Florida Photographic Collection, State Archives.*

In the end, the secret team accomplished a huge feat, as Foglesong writes: "assembling a 43-square-mile parcel twice the size of Manhattan and about the same size as San Francisco."

The reported average sale price for much of the land was about $200 an acre; when the news broke, asking prices rose to $1,000 an acre near the site.

One of the oft-repeated chapters of mystery-industry lore in Orlando maintains that Martin Andersen, the *Sentinel*'s owner and editor, and his equally powerful friend, attorney and banker Billy Dial, knew the identity of Disney and "stonewalled the news."

That's how writer Bill Belleville, now Florida's leading environmental author, phrased the charge in a 1977 *Florida Trend* article that Andersen attacked, although he did not deny having met with Helliwell and knowing a big deal was coming down. "Never did Helliwell, Dial or anyone else ever tell me it was a Disney project. And never did I ask," Andersen wrote in reply.

The story of this saga is well told in the late Ormund Powers's biography of Andersen and in Foglesong's book, both of which are essential reading about the forces that have shaped Central Florida.

One of those forces, of course, is the wild card factor. Often, what in retrospect seems like destiny could have played out a whole other way, in this case with Walt Disney World on the Mississippi.

During a visit to St. Louis in November 1963, Walt Disney had bubbled with enthusiasm as he envisioned a park with paddlewheel steamers like those in the tales of Mark Twain, Foglesong writes. But a local bigwig sent the deal down the river at a big dinner party to celebrate the union of St. Louis and the Walt Disney empire.

No beer sold at the place? It was unthinkable to beer king August "Gussie" Busch Jr. "Any man who thinks he can design an attraction that is going to be a success in this city and not serve beer or liquor ought to have his head examined," Busch reportedly said at the dinner.

That did it for Walt Disney. Finito. Outta there. As Foglesong says, it wasn't so much that the remark insulted his sense of morality; "it had insulted his business acumen." It was time to look seriously at Florida, Disney told his lieutenants.

On November 22, 1963, Disney and an entourage flew from Tampa in a plane borrowed from TV and radio host Arthur Godfrey. As they reached Orlando and circled south of the city, Walt looked down and saw the nexus of Interstate 4, then under construction, and Florida's Turnpike, both at Orlando in large part through the efforts of local power brokers Andersen and Dial.

"That's it," Walt said when he looked down from the plane, Foglesong writes.

Later, when the party landed in New Orleans, they saw people crying on the cab ride to their hotel and learned that President John Kennedy had been assassinated. It was a fateful day for the nation and, for entirely different reasons, a fateful day for Central Florida, as Foglesong writes.

In 1969, before Walt Disney World opened, 3.5 million tourists had visited Central Florida. Now, tourism officials say it's 50 million. In the minds of many visitors, the "industry" that was a mystery in the summer of 1965 is Orlando's sole reason for being.

BREAKING OUT OF
JUNE CLEAVER LAND

Come on in, we're having a Tupperware party. You don't have to buy anything—just spend a few fun minutes with ladies like the group in one of my favorite photos from the state's great online archive, the Florida Photographic Collection at Floridamemory.com. In glorious black and white, this quartet smiles and waves at us from 1960, decked out in wacky hats made of kitchen colanders. "Sales representatives in 'spacettes' costumes pose before the rocket entranceway of Tupperware Home Parties Inc.: Orlando, Florida," the caption reads. Tupperware, by the way, has long used an Orlando address, although locals know that its South Orange Blossom Trail headquarters, where the spacettes once roamed, is closer to Kissimmee.

The mail just arrived with my vintage red lunch kit, just like one I first bought at a real Tupperware party in Virginia about twenty-five years ago. I got it on eBay. Not only am I a pushover for old stuff, especially when the purchase can be deemed "an icon" of American design, but I encountered on the giant online auction site such an astounding array of vintage Tupperware that all willpower to resist was gone.

More than ten thousand listings came up: everything from "Pour-n-Store" pitchers to luncheon plates, divided trays to salad tongs.

Ah, those tongs. "Jadeite Jade green TONGS-Retro-Tupperware," at a starting bid of $1.50. One of them was damaged, but the seller, a twenty-year "Former Tupperware Lady" in Iowa showed her mettle by reminding potential buyers that even if the set were partially broken, a "collector may just need the 'good' part!"

The Iowa veteran also noted that Tupperware comes with a "lifetime guarantee against chipping, cracking or peeling." That probably explains why, if you could peek into all the cupboards in America's kitchens, you'd find (along with dead palmetto bugs) at least one piece of Tupperware lurking there, even if it is fifty years old.

More than Earl Tupper's innovative method for molding plastic, though, or the designs that landed Tupperware in museums, it was the way the stuff was sold that made it an American icon.

In the 1950s and early '60s, the Tupperware home party was a feminine domain in a business world where most doors were shut to women.

In the 1950s and '60s, being a "Tupperware lady" offered women a chance to earn money and test their wings in the work world. These "spacettes" posed at the company's Orlando-area headquarters in August 1960 as part of the company's annual "jubilee" for top salespeople. *Florida Photographic Collection, State Archives.*

Now, there was a time—about the time when I bought my first lunch kit at a Tupperware party in the 1970s—when I would have looked at these ladies from 1960 and thought, "poor things." They were stuck in June Cleaver land, the thinking went, housewives selling silly kitchen stuff to other housewives at campy parties, not doing "real work" in an office.

Yep, that's what I might have said about 1970. But, to quote Mr. Bob Dylan, I was so much older then; I'm younger than that now.

These ladies were doing the best they could, making some money and having some fun, trading in their garter belts and girdles for slacks and tennis shoes in Florida at an annual party, the jubilee, where they were treated like queens. And the queen of Tupperware in the 1950s, Brownie Wise, showed them how.

"What a lady," the *Orlando Sentinel*'s Don Boyett wrote in September 1992 after Wise died at her Kissimmee home at seventy-nine. "She had more business sense than a Harvard MBA. She knew people."

"If we build the people," Wise said, "they'll build the business." She summarized her philosophy in a motivational book titled *Best Wishes, Brownie Wise*, published in 1957. Your dreams aren't impossible, she told women, if you think big and work hard.

It's advice that's hard to beat.

She gave them her own example as a model. Forget about Martha Stewart; Brownie Wise gave American women a smart, savvy example of a woman making good in a man's world, a real rarity at the time.

"Boss Wise is a Lady," read the headline of a 1954 news profile. "One can picture this gracious young woman whose features are cameo-cut pouring tea in the Florida room of her picturesque estate, Waters Edge, on the eastern shore of Lake Tohopekaliga. Instead, she not only directs the bright young men on her personal staff with the deft sureness of a field general, but she also serves as the inspiration for a vast army of 9,000 Tupperware dealers throughout the nation."

Golly, I could go for that life. That's what a lot of "Tupperware ladies" figured, too.

Increasingly, social historians seem to be taking the role Wise and Tupperware parties played in the 1950s and early 1960s much more seriously. A recent article on the online *Harvard University Gazette* touted a campus showing of a documentary film by Laurie Kahn-Leavitt, a fellow at Harvard's prestigious Charles Warren Center for Studies in American History. Titled *Tupperware!*, the film makes the case that the era and the business were made for each other.

"As America's postwar economy exploded, women—many of whom worked during World War II—had few economic choices. They were discouraged from joining the man's world of work…While Tupper's patented containers…tapped into the nation's growing love affair with modern home conveniences, it was Wise's home-party selling that made the profitable connection with American women," the article says.

And so, those spacettes may look as if they're just having a bit of fun on a Florida vacation—but they were really breaking new ground in the business world for women.

And the green salad tongs? The broken ones I found on eBay? I found another, good pair for only four dollars. They should be arriving any day now.

FOR MOM AND DAD

If things had gone in the predictable way, my family would still be near Pittsburgh, in towns such as Beaver and Beaver Falls where they grew up. But like so many others of the generation shaped by World War II, they came to Florida after the war and began new lives, far from childhood friends and the support of a familiar landscape. My parents' experience in the years after World War II represents that of many other veterans and their wives who, having survived a life-changing drama of worldwide dimensions, found hope and optimism in Orlando, Florida.

Recently, a compulsion to acquire new sequined sandals just like my friend Loretta's drew me into a big box store. After the cashier tested my twenty-dollar bill for authenticity with a yellow marker, I had to stand in a creeping line and show my receipt to get out the door. It was a little like going through airport security, and you know what fun that is. Not your mother's kind of retail experience. In the case of my mother, Jean Dickinson, that sentence has special meaning.

For about twenty years, my mother worked in what was then called "personnel" for Jordan Marsh, a vanished group of department stores. For much of that time, she was the training supervisor at the four-story mother store in Orlando, which opened in 1962.

Not only regular employees, but also all summer and Christmas workers, many of them students, would pass through her domain, where they learned both the intricacies of the cash register and such niceties as saying, "Thank you for shopping with us, Mrs. Moneypenny."

It seemed as if she knew everyone, literally. Even years later, people seemed to pop out of the blue to greet her in restaurants, stores, movies. "Hi, Mrs. Dickinson, remember me? I worked at JM in 1966!" Once, in California during the late 1980s, my mother and I were visiting one of the old Spanish missions, thousands of miles from Orlando. There were only about twenty people in the place, one of whom spotted my mother and blurted out, "My god, it's you."

My mother's mother, Alice Swanson Wallace, and her mother, Sophia Swanson, who came to this country from Sweden, had not worked outside the home, although they certainly worked hard in their lives. That was the way things were for most women for much of the twentieth century.

Jean Dickinson (center) shows off her daughter, Joy, to her mother, Alice Swanson Wallace (left), and her mother's mother, Sophia Swanson, in Beaver, Pennsylvania. Later, Jean Dickinson took World War II work experience into retailing at Jordan Marsh. *Collection of Joy Wallace Dickinson.*

But like many other women, Jean Dickinson had gone to work during World War II, in a Curtiss-Wright aircraft plant near her home in Pennsylvania.

A fine painter, although she would disagree, she had graduated from what was then Beaver College for women in Philadelphia, where her teachers included Benton Spruance and Robert Gwathmey, both well-regarded American artists.

The war effort didn't call for many artists and illustrators, though; she worked in personnel at Curtiss-Wright and then left to join her new husband at army bases in Massachusetts and South Carolina before he went overseas.

On V-J Day, while he was still across the globe, she and her girlhood pal Mary Ray danced in the streets with the rest of Beaver, Pennsylvania.

A few years later when we moved to Florida and she had a small child, my mother pitched in at the new family venture, a grocery store on U.S. Highway 17-92 in Winter Park. She remembers the first time my dad and grandfather left her there alone behind the cash register, smiling bravely among the fresh gladioluses, milk, bread and baskets of citrus. She wasn't much more than thirty. What have I gotten into? she thought.

During the early 1950s, she led a Brownie Scout troop and volunteered at Hillcrest Elementary, but she had found a way to use her art skills, too. Studio

photographers then employed artists to hand-color portraits for clients with special photo oils. I can still smell the solvents, see the paints in small pastel dabs spread out on a wooden palette, with the bits of cotton and tiny brushes she used to bring black-and-white images of people to life.

The Orlando area didn't long stay strange territory for my mother. She liked to explore, on long Sunday drives that often involved a stop at our grocery store for an ice cream bar or a soda.

She would find the fastest and most ingenious shortcuts. No clogged Colonial Drive for her; if there was a way around it, she would find it.

That sense of direction and driving skill stood her in good stead during her next part-time job, as a Welcome Wagon hostess, calling on newcomers with welcome baskets of samples and coupons and organizing clubs for women to get to know one another. Many of them said hello to her for years, too.

Then along came Jordan Marsh, with the job of a lifetime for Jean Dickinson. She has good stories from those days—stories about celebrity visitors, stories about training trips to Miami in a twelve-seater plane, stories about happy times like the big sales when employees dressed in Gay Nineties costumes and put on rousing skits at meetings. And there are stories about the hard times, like the day she had to tell an elderly lady her husband had suddenly died in another department of an apparent heart attack.

Even in the hard times, though, I have a feeling each day was an adventure, like the back roads in Orange County she would roam with family along on Sundays. It was her territory. She knew people and they knew her.

And her daughter, who grew up in a world where opportunities for women seemed limited, absorbed the idea that a job was a pretty good thing.

Now, even in the stores where they don't test your money in front of you or tell you how many items you can take to the fitting room, are we really having much fun on either side of the cash register? After all, the sparkly sandals aren't really what's important, are they? In life, it's our day-to-day experience that matters.

So, truly, have a good day, Ms. Moneypenny. However long you stay in Orlando, Florida, may you too find under its palm trees and blue skies both a home and an adventure.

In early 2005, my Uncle Paul died in Beaver, Pennsylvania. It was such a shock. I thought I would be able to visit him for years—but like his big brother, my dad, his lungs gave out too soon. The Dickinson brothers began smoking young. That's what cool guys did in those days. They didn't know they were, of course; really cool guys don't.

A few years ago Paul gave me a picture of my dad from about 1933. He's sixteen in the photo, the age he was when Paul was born. He had a lot on his mind. My grandmother, pregnant in her forties with Paul, nearly died during the delivery. There's a family story that my dad walked at night a long way in the snow to see his mother in the hospital. He and his sister, Nora, who still lives near Pittsburgh, must have been very worried.

The son of a railroad engineer, George W. Dickinson was stationed in the Philippines during World War II (above). Four years after the war's end, he moved with his family to Florida, where he became a grocer and lived in Orlando for the rest of his life. *Collection of Joy Wallace Dickinson.*

Their dad, George N. Dickinson, was a railroad engineer. Their mom, Florence Durbin Dickinson, did pull through the delivery and lived well into her eighties, far beyond her husband, who died of a heart attack at the throttle of his train.

Both of my dad's parents were probably Irish. She definitely was. His name, Dickinson, was an English acquisition via his stepfather, a passenger-train conductor when such a job carried status in the railroad towns of western Pennsylvania. Perhaps from Mr. Dickinson, my grandfather acquired the penchant for cutting a fine figure, which he passed to his sons. No overalls for his go-to-work attire: he left home in starched white collars and the mark of a gentleman—a good hat.

His sons, George and Paul, children of working-class roots, knew how to dress as well as anyone, in any class.

My dad could be very funny. To socialize with a group of couples who deemed themselves the Lotta Club, my parents would leave the house on Saturday nights in the 1950s in zany costumes, including the Marx Brothers. She was Groucho; he made an angelic Harpo.

Much of the time, though, he was serious. He was supposed to be The Dad, the man who made sure food was on the table and everyone had what they needed. I was only able to understand relatively late in his life the weight that this provider role must have carried, especially for children of the Depression such as my father.

He did use banks, but he also kept a small stash of real money tucked under the folded linens in the bathroom closet. You had to be prepared. The wolf at the door might have gone into hiding, but it could be lurking around the corner.

He liked television. Before Orlando had its own station, he would look forward to catching Sid Caesar or Milton Berle coming in from Jacksonville if the weather or the stars were right. He'd even get up on the flat roof of our stucco house to adjust the TV antenna, turning it to catch the signal better. Sometimes a small tube would give out in the bowels of the big wooden TV cabinet, and in an elaborate ritual that involved hand mirrors and screwdrivers and a good amount of perspiration, he and my mother would locate the culprit and rush out to replace it.

He worked long hours at his grocery in Winter Park, which opened early and closed late. After he got home, he and my mother would unwind with Steve Allen or Jack Paar on TV. If she had gone to bed earlier, the next day he would tell her about the exploits of the regular guests—maybe a fellow named Jack Douglas, who had a charming Japanese wife, or the great jazz pianist Erroll Garner, one of my dad's favorites.

On Saturday nights, we would watch Jackie Gleason, The Great One. He was indeed great, but it was Art Carney as his sidekick, Ed Norton, who made my dad laugh out loud.

Each Christmas, he and my mother would send cards to faraway addresses in Iowa and New York, to men he had known in World War II. Occasionally, one of them would appear for a visit on a trip through Florida, where the Dickinsons had moved after the war, like so many other families.

My dad had his first Father's Day in the Philippines, after World War II had ended in Europe but before V-J Day.

In a letter he wrote his grandparents postmarked June 1945, he says the food is getting a little better—they even had some fresh vegetables and fresh apples, and they got to see movies three nights a week.

"We're certainly glad to hear the war's all over in Europe and that undoubtedly should hasten the war's end over here a lot, although there's still plenty to do," he writes. "I received some pictures of my daughter for the first time the other day…Gosh, I can't wait until this old war is all over so that I can get home to my wife and baby."

I hadn't looked at the letter for years before I got it out last week. It looks startlingly fresh. Could it have been so many years since my Dad's strokes of a pen crossed the paper? The letter stays in an old stationery box, tucked with a few other treasures in a drawer under some linens, like my Dad's linen closet stash of cash.

He's been gone almost twenty years now. On Father's Day, I buy cards for my brother. There are no more bottles of Old Spice aftershave, my childhood gift of choice for my dad. There are no more ties. There are no more cards to my Uncle Paul, one of the dearest men in the world. But with some treasures, like that letter tucked away along with the pictures in my mind, I'll be rich, even if there is another Depression. You will be too, you know—the best things in life really are free.

MISSING RONNIE'S

There's one lost landmark Orlandoans and visitors miss like no other. Here's a hint: "Mogambo Extravaganza." If those words bring to mind an old movie starring Ava Gardner or a Rosemary Clooney tune, you're on the wrong track. If they conjure an image of a mountain of ice cream, you know the subject is Ronnie's Restaurant and Bakery. For nearly forty years, Larry Leckart's establishment at the original Colonial Plaza embodied much more than good things to eat. It was a center of community.

We went here after a movie, and got something called a Mogambo," an unknown correspondent wrote years ago on a postcard from Orlando, in tidy fountain pen script. "Seven flavors of ice cream with a topping of whipped cream 8 inches high & with caramel syrup, too!"

The "here" was Ronnie's, the Orlando institution on East Colonial Drive that began in 1956 and ended in February 1995. Its owner, Larry Leckart, closed Ronnie's the same day Colonial Plaza Mall was sold to an Atlanta company that tore down the original 1950s mall and replaced it with Colonial Plaza's current incarnation.

In its nearly forty years of looming large as a Central Florida institution, Ronnie's served not only the Mogambo but a wide variety of deli treats from borscht to blintzes, plus hot roast beef sandwiches, cheeseburgers, corned beef hash—and on and on.

The menu was enormous. The salads and platters featured Columbia River salmon, imported Portuguese sardines (individual tin) and "Roumanian pastrami." The "taste appealing appetizers" included chopped liver and jumbo shrimp cocktail, and the "daily specials" ranged from two frankfurters with baked beans to barbecue beef on bun to prime rib with mashed potatoes and gravy.

Hungry? Save room for dessert.

That was the section of the menu where the Mogambo Extravaganza reigned as the ultimate ice cream sundae. "This sundae should only be served to two or more people…if you are alone…hesitate to order it," read the menu—which of course only egged on the preteen crowd, dropped off by parents after dances to walk on the wild side of all that chocolate, vanilla, strawberry, coffee, butter pecan, orange and lime had to offer.

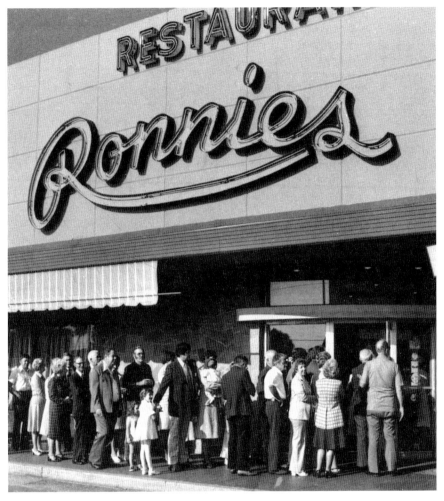

It's been more than a decade since it closed but Orlandoans still miss Ronnie's Restaurant & Bakery, the Central Florida institution on East Colonial Drive that began in 1956 and ended in February 1995. Orlando Sentinel *files*.

Some of the soda-fountain confections bore names with a local twist. The Rollins Special involved a cream puff shell filled with ice cream and hot fudge, while The Pinecastle combined pineapple ice cream and marshmallow topping. The Lake Sue mixed coffee ice cream and hot fudge. A couple of the names, the Matador and the Apollo, offered a tip of the ice cream scoop to the folks over on the Space Coast. Customers traveled from Cocoa or Melbourne—all over Central Florida—to dine at Ronnie's.

As then Orange County Chairman Linda Chapin said when the place closed in 1995, "Ronnie's was the only place this side of the Mason-Dixon where you could get a great hot pastrami sandwich."

But back to the sweets. We haven't even begun to think about the items from the bake shop that adjoined the restaurant: Napoleons and Black Forest cake, strawberry cheesecake, bread pudding, fresh apple pie (with or without American cheese). And there were the rolls, also fresh from the bakery. For diners who ordered platters or dinners, baskets of chewy pumpernickel, kaiser and other varieties could appear on your Formica table, with real butter.

As the menu carefully pointed out, though, the rolls and butter were not included with everything. The "R" in Ronnie's, you see, might also have stood for "rules," and thereupon rests part of the Ronnie's legend. In fact, at one time it seemed that the best way to spark a loud feud in the middle of the *Orlando Sentinel* newsroom (and other area workplaces) would be to bring up the subject of Ronnie's.

Declaim your love for the place, and someone would unleash a long-nursed grudge about the time he or she had asked for more butter for their pancakes and been rebuffed, or the time they had stood in the wrong line to wait for a table and been told to move, or other affronts to a diner's ego.

"They talk about the abrupt service, but that's part of what we liked," Barbara Bass of Orlando told the *Sentinel* on the eatery's closing night. "It was like having your mother serve you," said Steven Bass, her husband. That's how many of us felt about it, except that our mothers never would have allowed us the indulgence of a Mogambo Extravaganza.

When Ronnie's closed in 1995, then–Orange County Commissioner Bill Donegan gasped when told the news. "Ronnie's was for me a touchy-feely place—a place I could go to interact with a large cross-section of Orlando," Donegan said. "Ronnie's was Main Street America—no, Main Street, Orlando. It will be sorely missed."

Amen, commissioner. So let's lift a glass—or an ice cream scoop—to Ronnie's, with its big swoopy neon sign that Orlando's dean of sign design, Bob Galler, remembers as his favorite. Let's toast its wooden telephone booths—the kind where you sat down to make a call, enveloped by folding glass doors in your own private world.

Let's pause, too, to honor that eternal coffee shop decor, which in the 1990s seemed to have not changed an iota from the day Ronnie's opened in 1956. But most of all, let's recall pumpernickel and pickles and pastrami and hot fudge—not together, of course, unless you'd like that. Guess we have to make up our own rules now.

SELECTED BIBLIOGRAPHY

Bacon, Eve. *Orlando: A Centennial History*. 2 vols. Chuluota, FL: Mickler House, 1975.

Beatty, Bob. *Florida's Highwaymen: Legendary Landscapes*. Orlando: Historical Society of Central Florida, 2005.

Bentley, Elizabeth Bradley. *A Side Walk Through the Art Festival*. Winter Park: Winter Park Sidewalk Art Festival, 1979.

Bogen, Gil. *Tinker, Evers, and Chance: A Triple Biography*. Jefferson, NC: McFarland & Company, Inc., 2003.

Brotemarkle, Benjamin D. *Beyond the Theme Parks: Exploring Central Florida*. Gainesville: University Press of Florida, 1999.

————. *Crossing Division Street: An Oral History of the African-American Community in Orlando*. Cocoa: The Florida Historical Society Press, 2005.

Campen, Richard N. *Winter Park Portrait: The Story of Winter Park and Rollins College*. 2nd ed. Winter Park: Winter Park Historical Association, 1998.

Chapman, Robin. *The Absolutely Essential Guide to Orlando: Where the World Goes on Vacation*. Winter Park, FL: The Absolutely Essential Company, 2003.

————. *The Absolutely Essential Guide to Winter Park: The Village in the Heart of Central Florida*. 2nd ed. Winter Park, FL: The Absolutely Essential Company, 2001.

Deitche, Scott M. *Cigar City Mafia: A Complete History of the Tampa Underworld*. Fort Lee, NJ: Barricade Books, 2004.

Foglesong, Richard E. *Married to the Mouse: Walt Disney World and Orlando*. New Haven, CT: Yale University Press, 2001.

Florida Department of State, Division of Historical Resources. *Florida Black Heritage Trail*. Tallahassee: A Florida Heritage Publication, 1994.

————. *Florida Jewish Heritage Trail*. Tallahassee: A Florida Heritage Publication, 2000.

Gannon, Michael, ed. *The New History of Florida*. Gainesville: University Press of Florida, 1996.

Gannon, Michael. *Florida: A Short History*. Revised edition, Gainesville: University Press of Florida, 2003.

Gore, E.H. *History of Orlando*. Orlando: Academy Press, 1949.

Green, Amy Boothe, and Howard E. Green. *Remembering Walt: Favorite Memories of Walt Disney*. New York: Hyperion, 1999.

Guide to Florida's Historic Architecture. Gainesville: University Press of Florida, 1989.

Guralnick, Peter. *Last Train to Memphis: The Rise of Elvis Presley*. Boston: Little, Brown, 1994.

Hinton, Ed. *Daytona: From the Birth of Speed to the Death of the Man in Black*. New York: Warner Books, 2002.

Jahoda, Gloria. *Florida: A History*. New York: W.W. Norton, for the American Association for State and Local History, Nashville, TN, 1976.

Kealing, Bob. "Brownie Wise: The Rise and Fall of Sunshine Cinderella," *Reflections from Central Florida* (Historical Society of Central Florida) 3, no. 4 (October 2005).

————. *Kerouac in Florida: Where the Road Ends*. Orlando: Arbiter Press, 2004.

MacDowell, Claire Leavitt. "Chronological History of Winter Park, Florida." Winter Park, FL: Privately published, 1950.

McPhee, John. *Oranges*. 1967. Reprinted with new preface, New York: Farrar, Straus and Giroux, 2000.

Monroe, Gary. *The Highwaymen: Florida's African-American Landscape Painters*. Gainesville: University Press of Florida, 2001.

Mormino, Gary. *Land of Sunshine, State of Dreams: A Social History of Modern Florida*. Gainesville: University Press of Florida, 2005.

O'Sullivan, Maurice, and Jack C. Lane, eds. *The Florida Reader: Visions of Paradise from 1530 to the Present*. Sarasota, FL: Pineapple Press, 1991.

Powers, Ormund. *Martin Andersen: Editor, Publisher, Galley Boy*. Chicago: Contemporary Books, 1996.

Rajtar, Steve. *Orlando Greenwood Cemetery Historical Trail: A Visit with Over 425 Historic Orlandoans at Their Final Resting Place*. Orlando: Central Florida Genealogical Society, 2003.

Rivalries: The Tradition of Georgia vs. Florida. DVD. Narrated by Pat Summerall. Hart Sharp Video, 2003.

Robison, Jim, and Mark Andrews. *Flashbacks: The Story of Central Florida's Past*. Orlando: Orange County Historical Society and the *Orlando Sentinel*, 1995.

Ste.Claire, Dana. *Cracker: The Cracker Culture in Florida History*. Daytona Beach, FL: The Museum of Arts and Sciences, 1998.

Schickel, Richard. *The Disney Version: The Life, Times, Art and Commerce of Walt Disney*. 3rd ed. Chicago: Ivan R. Dee, Incorporated, 1997.

Shofner, Jerrell H. *Orlando: The City Beautiful*. Tulsa, OK: Continental Heritage Press, 1984.

Smith, Patrick D. *A Land Remembered*. Sarasota, FL: Pineapple Press, 1984.

Swanson, Henry F. "Countdown for Agriculture in Orange County, Florida." Orlando: Privately published, 1975.

Thompson, Geraldine Fortenberry. *Orlando, Florida*. Black America Series. Charleston, SC: Arcadia Publishing, 2003.

Winter Garden Heritage Foundation. *All Aboard! A Journey Through Historic Winter Garden, 1880–1950*. Winter Garden, FL, 1997.

ONLINE RESOURCES

Central Florida Genealogical Society: cfgs.org

Central Florida Heritage Foundation: cfhf.net

Central Florida Historial Trail Series: geocities.com/yosemite/rapids/8428/historicalseries.html

Central Florida Memory Project: centralfloridamemory.lib.ucf.edu

Florida Heritage Collection: susdl.fcla.edu/fh

Florida Historical Quarterly: pegasus.cc.ucf.edu/~flhisqtr/quarterly.html

Florida Photographic Collection: floridamemory.com/PhotographicCollection

Orange County Regional History Center: thehistorycenter.org

Orlando Sentinel archives: orlandosentinel.com

Orlando Remembered: cityoforlando.net/orlrem

Winter Park Public Library, Winter Park History and Archives Collection: wppl.org/wphistory/DigitizedCollections.htm

INDEX

INDEX